£4-99

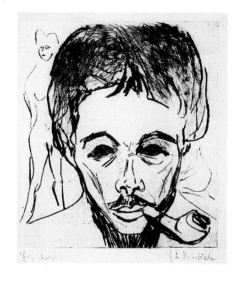

3

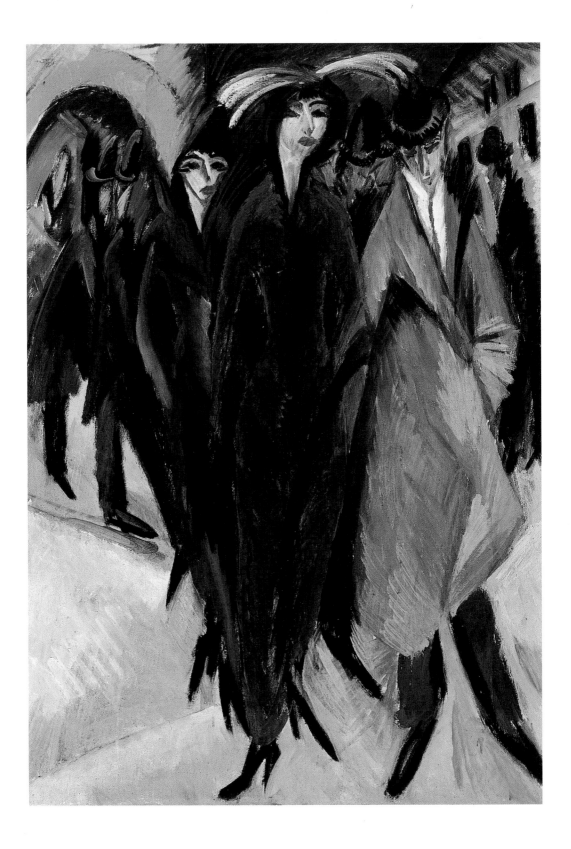

Norbert Wolf

ERNST LUDWIG KIRCHNER

1880–1938

On the Edge of the Abyss of Time

TASCHEN

KÖLN LONDON LOS ANGELES MADRID PARIS TOKYO

COVER:
Two Women with a Washbasin (detail), 1913
Oil on canvas, 121 x 90.5 cm
Frankfurt am Main, Städtische Galerie im
Städelschen Kunstinstitut

BACK COVER:
Ernst Ludwig Kirchner in Chemnitz with
the works he had done in Munich, 1904

PAGE 1:
Self-Portrait with Pipe, 1908
Drypoint, 22.2 x 20 cm
Essen, Museum Folkwang

PAGE 2:
Women in the Street, 1915
Oil on canvas, 126 x 90 cm
Wuppertal, Von der Heydt-Museum

© 2003 TASCHEN GmbH
Hohenzollernring 53, D–50672 Köln
www.taschen.com

© for the works of Ernst Ludwig Kirchner: Dr. Wolfgang & Ingeborg Henze-Ketterer,
Wichtrach/Berne; © for the work of Karl Schmidt-Rottluff: VG Bild-Kunst, Bonn 2003;
© for the work of Henri Matisse: Succession H. Matisse / VG Bild-Kunst, Bonn 2003; © for the work of
Edvard Munch: The Munch Museum / The Munch Ellingsen Group / VG Bild-Kunst, Bonn 2003
© for the works of Max Pechstein: Max Pechstein Urheberrechtsgemeinschaft, Hamburg/Tökendorf 2003
Project management: Juliane Steinbrecher, Cologne
Editing and layout: stilistico, Cologne
Translation: John William Gabriel, Worpswede
Cover design: Catinka Keul and Angelika Taschen, Cologne
Production: Stefan Klatte, Cologne

Printed in Germany
ISBN 3–8228–2123–3

Contents

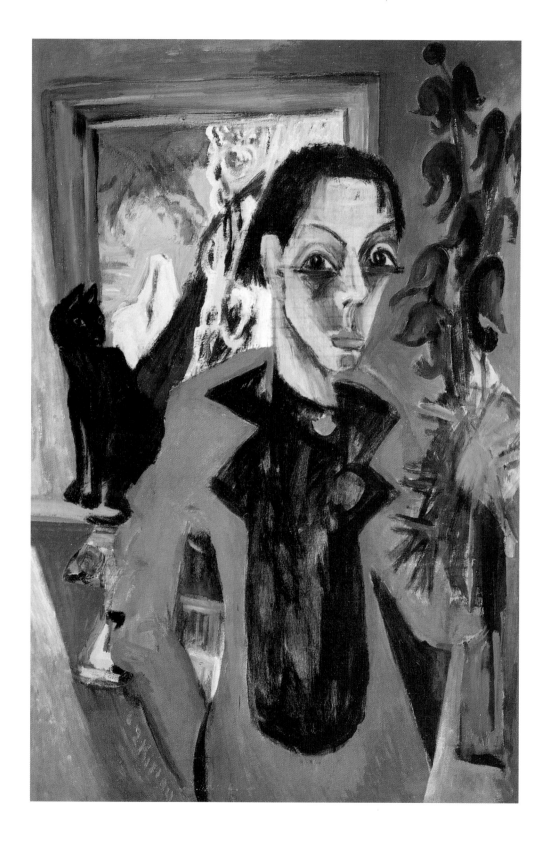

"What urges them to create"

"Now it's Heckeling and Kirchnering from every wall," complained an art critic in 1920 in view of the inflation of Expressionist art, which had become the cultural trademark of the Weimar Republic after the First World War. Erich Heckel (1883–1970) and Ernst Ludwig Kirchner were the key protagonists of the style. In 1905 they had joined with like-minded artists in Dresden to form a group called Die Brücke, or The Bridge. Their manifesto, published the following year, appealed to a "new generation of both creators and lovers of art," to the young who would inherit the future – to anyone, in fact, who was capable of expressing "what urges them to create, directly and without adulteration."

Kirchner, most would now agree, was the leading light of Die Brücke. Today he is appreciated as one of the most significant artists not only of German modernism but of European modernism as a whole. Yet this consensus was by no means easily reached. Art critics have always found it difficult to evaluate his enormous œuvre and the obsessive effort that went into it. Like a chimera, Ernst Ludwig Kirchner's baffling metamorphoses have eluded facile categorization.

He was a good-looking man, the young Kirchner, judging by the photographs (ill. p. 93). Friends described the twenty-five-year-old – dark-haired, strikingly cut face, cigarette between his fingers or dangling from the corner of his mouth – as self-confident, devil-may-care, proud, passionate, gripped by an incessant creative fervor. The uncompromising aspect of his character, which was soon to turn self-destructive, is compellingly reflected in his *Self-Portrait* of 1914 (ill. p. 11). In his later *Self-Portrait with Cat* (ill. p. 6), in contrast, the artist's appearance has the enigmatic Egyptian aura of a feline god, with schematically outlined eyelids, sunken eye sockets, dark cheeks, and elongated squarish chin. After the gruelling war years, Kirchner's physical body appears to have become increasingly permeable to the mysteries of the psyche. Intense planes of colour clash and overlap; deep, hidden strata of the mind seem to press towards the surface. The human figure becomes a palimpsest, in which suggestions of obscured symbols of a long-gone past shine through the script of the now.

The beginnings of Expressionism, and with them Kirchner's first attempts to find his artistic feet, fell in a period that was rife with tensions. Kaiser Wilhelm II, King of Prussia and Emperor of the German Reich, had a poor reputation among artists outside the conservative, academic circles favoured by his court.

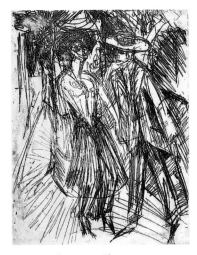

Cocotte Proffering Herself, 1914
Drypoint and corrosion, 35.1 x 27.1 cm
Berlin, Brücke-Museum

Self-Portrait with a Cat, 1919/20
Oil on canvas, 120 x 85 cm
Cambridge (MA), Courtesy of The Busch-Reisinger Harvard University Art Museums, Museum's Purchase

This painting was apparently begun at Stafelalp, Switzerland, in 1919, but was not finished until spring 1920. In April 1920 it hung, on loan from Kirchner, in the house of the Spengler family in Davos.

His taste, they scoffed, was as kitschy and pompous as that of "a scullion or baker's boy". This dilettante on the throne superciliously denounced the socially committed art of Käthe Kollwitz (1867–1945) and the Impressionism of Max Liebermann (1847–1935) as "gutter art," and ranted against the Expressionists. Foreign avant-garde art was even more of an anathema to him. Unadmitted envy of the world capital of art, Paris, certainly played a role here, since all of the revolutionary decisions that shaped modern art had been taken in France. The Impressionists had been followed by the Post-Impressionists and the great lone wolves Paul Cézanne (1839–1906), Vincent van Gogh (1853–1890) and Paul Gauguin (1848–1903). Then came the Nabis, with their generous planar treatment of form and penchant for the daringly decorative. In the early twentieth century, the course of modern art began to be shaped by the Fauves. From outside France, an eminent influence came from the Norwegian, Edvard Munch (1863–1944), who in turn owed a great deal to his various periods of study in Paris.

Nowhere were these currents registered more enthusiastically than in the officially so philistine Wilhelmine Germany. Prior to the First World War, liberal museum directors, progressive art historians, open-minded collectors and dealers had ensured that imperial salon painting would not have a monopoly on setting the tone, and encouraged that very "gutter art" the powers-that-be despised. On July 3, 1914, the French poet and art critic Guillaume Apollinaire (1880–1919) wrote in the *Paris-Journal*, "As far as French art is concerned,

Milly Sleeping, 1911
Oil on canvas, 64 x 90.5 cm
Bremen, Kunsthalle Bremen

Milly, with Nelly and Sam, belonged to a group of black circus artistes who often modelled for Heckel and Kirchner at that period.

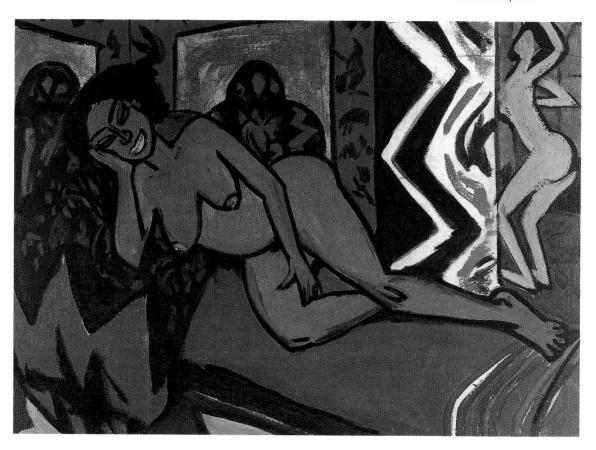

Two Nude Girls in the Studio, 1909
Coloured chalks on paper, 34.5 x 43 cm
Kassel, Staatliche Museen Kassel,
Graphische Sammlung

the light definitely comes to us today from Germany. Not a day passes without
an exhibition of a new French artist opening in Berlin, Munich, Düsseldorf or
Cologne."

German Expressionism was a vehement reply to the diverse "isms" of the
avant-garde. In the exhibition catalogue of the XXII Berlin Secession of 1911,
young French Fauvists and Cubists were still listed under the rubric of "Expres-
sionists". In his 1918 book *Expressionismus, die Kunstwende* (Expressionism, the
Turning Point in Art), Herwarth Walden likewise subsumed Italian Futurists,
French Cubists and Der Blaue Reiter of Munich under this term. On the other
hand, in his 1914 book *Der Expressionismus*, Paul Fechter had already limited
this stylistic category to Die Brücke and Der Blaue Reiter, and thus to German
art. Max Pechstein (1881–1955), a member of Die Brücke until 1912, retrospec-
tively boiled Expressionism down to its radical quintessence in 1920, exclaim-
ing that it was "Work! Intoxication! Brain racking! Chewing, eating, gorging,
rooting up! Rapturous birth pangs! Jabbing of the brush, preferably right
through the canvas. Trampling on paint tubes…" Shock, provocation, a revolt
of the young against the hidebound establishment – this was the Expressionists'
credo.

Just a glimpse into Kirchner's Berlin studio would likely have been enough
to shock the day's respectable citizens. They would have seen a bohemian dissi-
pation that confirmed the prejudice against "gutter art". In one photo of Kirch-
ner and his later companion, Erna Schilling (ill. p. 94), his studio on Durlacher
Strasse recalls a gloomy opium den, an exotic ambience furnished with African-
looking wood sculptures and a Japanese parasol. His subsequent studio and
apartment on Körnerstrasse, where he moved in 1913, was likewise stylized into
a provocative environment, crammed with sculptures and paintings (some of
them copulation scenes), wall hangings and tablecloths made by his girlfriend,
and homemade furniture. It was like a garish stage on which the artist could

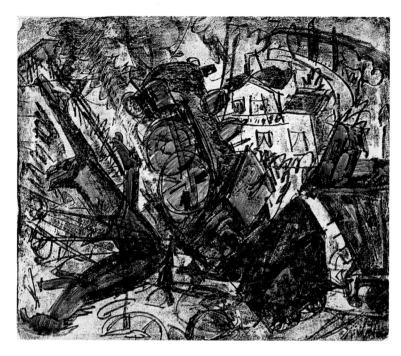

The Railway Accident, 1914
Colour lithograph in black and violet,
50.5 x 59.5 cm
Berlin, Brücke-Museum

This lithograph is one of three illustrations
Kirchner made to Emile Zola's novel *La Bête
humaine.* The train accident it represents was
arranged by an envious colleague of the novel's
protagonist, Jacques Lantier, in an attempt to
kill him.

play his self-chosen starring role, and flaunt his casual promiscuity, to the hilt
(ill. p. 92). Kirchner, his mistresses, friends, models and fellow artists (ill. p. 8),
vaudeville performers and dancing girls enjoyed themselves here in free-and-
easy nakedness, as their predecessors had back in Dresden (ill. p. 9). One of
Kirchner's first girlfriends, Line (pronounced lee-neh), was a music hall dancer
with whom he lived until the turn of the year 1906–07. He separated from her
when she got in trouble with the police.

 This display of exoticism and primitivism, along with free sexuality, were a
token of the Expressionists' untrammelled "naturalness", their love of life, their
creativity. Yet they were also intended as a challenge to the technocratic and
philistine world, a gesture of opposition, if one without political overtones.
French artists had begun to interest themselves in ethnological collections as
early as 1905, and had brought African masks and Oceanic statues into their
studios. This recourse to a supposedly primitive art was like a bohemian fist
shaken in the face of the bourgeoisie. Yet at the same time it reflected artists'
search for unsullied forms of expression in the realm of non-European culture.
The German Expressionists followed the Frenchmen's lead. In addition to maga-
zine photos of "Negro combos" and travel souvenirs from "underdeveloped
countries", museums of ethnology became just as much a source of inspiration
as "exotic" circus or cabaret performances. Primitivistic aspects dominated above
all in Expressionist representations of faces – angular noses, full lips, pointed
chins, an emphasis on the roughhewn that was complemented by exaggerated
gestures and poses.

 "E.L. Kirchner. Expressionist. Leader of the latest trend," wrote the artist
in 1912 or 1913 on the back of two portrait photos. This was the first and only
time he applied this stylistic term to himself, but perhaps it was only meant
ironically. There seems to be absolutely no irony, however, in the entry of March 1,

Self-Portrait, 1914
Oil on canvas, 65 x 47 cm
Berlin, Brücke-Museum

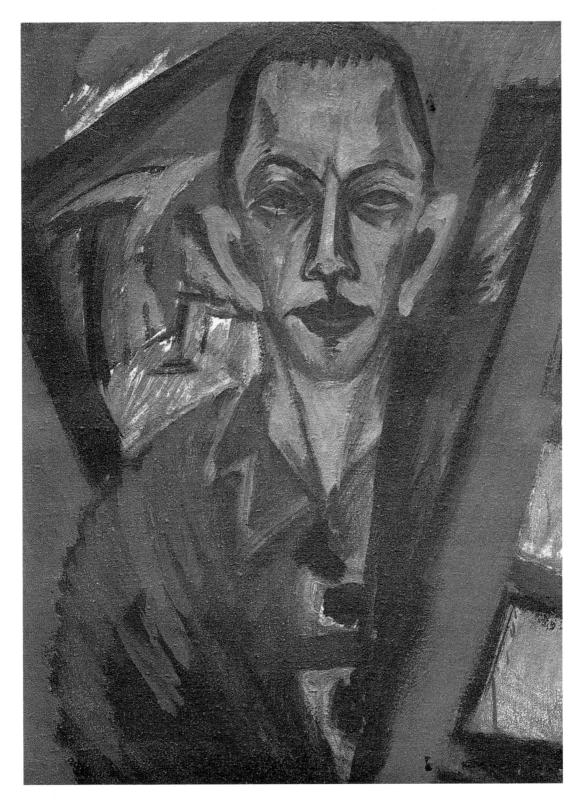

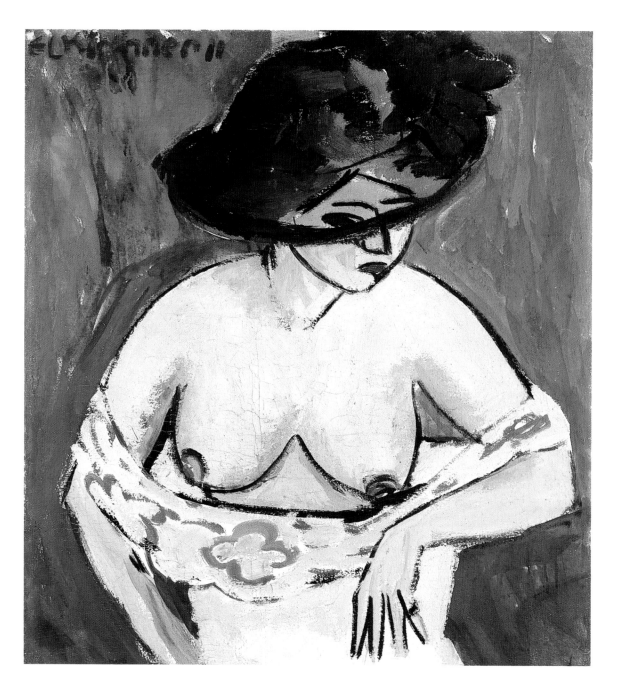

Female Nude with Hat, 1911
Oil on canvas, 76 x 70 cm
Cologne, Museum Ludwig

The sitter for this painting, Kirchner's first treatment
of the subject of a woman in dishabille, was Dodo, one
of the artist's mistresses during his Dresden period.

1923 in his Davos diary, where Kirchner calls himself "Germanic like no other artist". Two years later he declared, "Germanic art is religion in the widest sense of the word; Romance [i.e. French] art is reproduction, depiction, description or paraphrasing of nature. A German paints the 'what', a Frenchman the 'how' … There are only a very few German artists who have been pathfinders in design, since Dürer almost none." Kirchner counted himself among the few legitimate heirs of Dürer. He had tracked down form, he said, though of course not for its own sake in the sense of French "art for art's sake", but, as another diary entry states, as the "expression of his dreams", as the vehicle of something spiritual, transcendental. This claim on Kirchner's part conformed with the development of Expressionist art in the first third of the twentieth century. While enthusiastically adopting formal experiments and motifs from abroad, the Expressionists transformed them and put them in the service of their own idealistic visions.

A striking example of this is Kirchner's colour lithograph *The Railway Accident*, 1914 (ill. p. 10). The image is much more than an illustration to a novel by Émile Zola (1840–1902). The tumultuous drama of the event, the swiftly executed lineatures and hatchings, the brutal light-dark contrasts, all come together to form one of the most unusual big-city scenes in Kirchner's œuvre. A freight train has collided with a horsedrawn wagon. The derailed locomotive looms like an omen of death over the writhing animals. In stylistic terms, Kirchner uses devices from Italian Futurism to convey a simultaneous superimposition of several different sense impressions. With its diagonal lines of force radiating from the centre, the dynamic composition supplements the unreal colours to evoke a disquieting vision of a world that has gone out of joint. For unlike the Futurists, Kirchner sings no praises of technology here, instead emphasizing its potential for destruction and chaos. The image recalls the "… trains falling from bridges" in the Expressionist poet Jacob van Hoddis' "End of the World", 1911. Its explosive force also seems to anticipate the imminent apocalypse of the First World War.

A similarly aggressive atmosphere suffuses the drypoint etching *Cocotte Proffering Herself*, 1914 (ill. p. 7). The hectic pace of urban life is wonderfully captured in the nervous hatchings and tangles of line, which seem to penetrate to the depths of the figure's psyches. Woodcut was the congenial medium for Kirchner's feverish expressive urge. Especially his colour woodcuts come very close to the effects of Expressionist painting. The woodcut portrait, *Head of Ludwig Schames*, 1918, shows the entire range of the artist's formative powers, his ability to transmute a portrait into a spiritual symbol. The elongated head with its tensely charged interior drawing forms the intellectual opposite pole to the sensual naked body of the woman, whose contours interlock with those of the portrait. One of the most compelling graphic works of Expressionism, this image brings the elemental categories of nature and the human mind into symbiosis.

Kirchner's invocation of the "Germanic", an expressively emotional, indeed mystical "Teutonic" formal language, went back to such greats as Albrecht Dürer (1471–1528) or Lucas Cranach the Elder (1472–1553). However, this was a two-edged sword. The view found support in the philosophy of the then highly popular Friedrich Nietzsche (1844–1900) and the maxims on art expressed in such works of the 1880s as *The Birth of Tragedy*: "Art as the redemption of the seer – he who sees the terrible and dubious character of existence, wants to see it: the tragic seer. Art as the redemption of the doer – he who not only sees the terrible

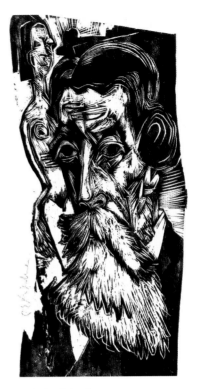

Head of Ludwig Schames, 1918
Woodcut, 56 x 25.5 cm
Berlin, Brücke-Museum

Prompted by the death of his friend and Frankfurt art dealer, Kirchner cut his portrait into an irregularly shaped wood block, fitting it into a narrow vertical format and adding a nude female figure.

and dubious character of existence but lives, wants to live: the tragic warrior, the hero. Art as the redemption of the sufferer – as a path to states in which suffering is willed, transfigured, deified, in which suffering is a form of the great ecstasy." Art as suffering and redemption, as a metaphysical outcry – this seemed to be the secret of the distortions and alienations of form which were supposedly typical of German art since the Middle Ages.

With their aid, Expressionists like Kirchner, working at fever pitch and with the courage to accept deformation and ugliness, attempted to see beneath the surface of empirical reality. "A painter paints the appearances of things," as Kirchner once put it, "not their objective correctness; in fact he creates new appearances of things." It was this artistic egocentrism that led to his subjectively exaggerated formal idiom and "unrealistic" colour schemes, understood as effusions of the artist's psyche.

Kirchner's mention of the transcendental "what" of German art was, at the same time, an ambivalent reaction to the then current view that culture and civilization represented opposite poles. To traditionalist minds, civilization was an offshoot of money and industrialism, as opposed to culture, which encompassed the arts and humanities and everything aesthetic. Civilization had emerged from rampant urbanization and the visible, ugly traces it left on modern life. The mission of art was to bypass the evils of civilization and evoke the harmony of bygone, happier days. Although the necessity of technological progress was undeniable, many Germans nonetheless demanded that art return to "the beautiful and true", to the virtues of early greats such as Dürer and the Gothic artists before him. In this view, culture was the birthright of the nature-loving, profoundly thinking Germans. "Accordingly we can say that we form the soul of humanity and that destruction of the German way would deprive world history of its profoundest meaning," declared Rudolf Eucken in 1914, in his book *Die welthistorische Bedeutung des deutschen Geistes* (The Significance of the German Mind in World History).

The French, in contrast, were thought of as a civilized people, cynical and superficially advanced, rationalistic and urbane. Luckily this cliché did not convince everyone in the art world. Two artists, the Russian El Lissitzky (1890–1941) and the Franco-German Hans (Jean) Arp (1887–1966), took issue with it in their book *The Art Isms,* 1925. "Cubism and Futurism were minced up to create mock hare, that metaphysical German meatloaf known as Expressionism," they scoffed. An understandable if equally exaggerated reaction in the opposite direction.

Was Kirchner really nothing but a maker of "German mock hare"? He was certainly no provincial highbrow or cultural romantic with nationalistic leanings. As his colleague, Max Beckmann (1884–1950), recognized in 1950, Kirchner's problem was precisely "his inability to resist French influence". Such influences indeed suffuse his œuvre, especially that of Fauvism and the luminous, flat colour planes of Henri Matisse (1869–1954). We need only compare the French artist's *Seated Girl,* painted in 1909, with Kirchner's portrait of the adolescent Marcella, 1909/10 (ill. p. 15), or his *Female Nude with Hat,* 1911 (ill. p. 12).

Nor was Kirchner the sheer emotionalist that many consider him to have been. Especially after 1920, the intellectual underpinning of his art grew increasingly important to him. He began to restore a number of paintings that were in poor condition after several moves, adapting them to his new ideas and suppressing their expressiveness in favour of a more considered, sober formal ap-

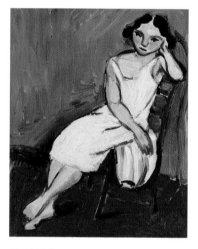

Henri Matisse
Seated Girl, 1909
Oil on canvas, 41.5 x 33.5 cm
Cologne, Museum Ludwig

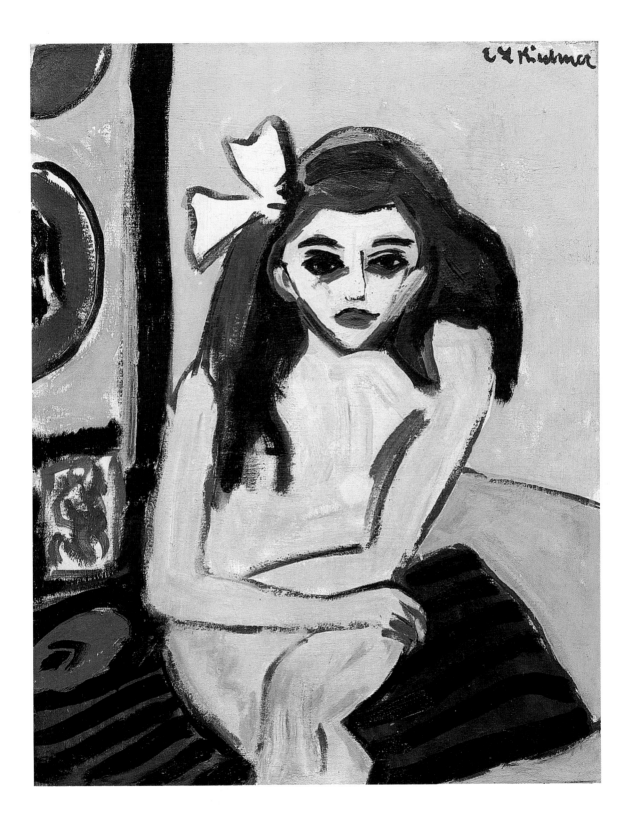

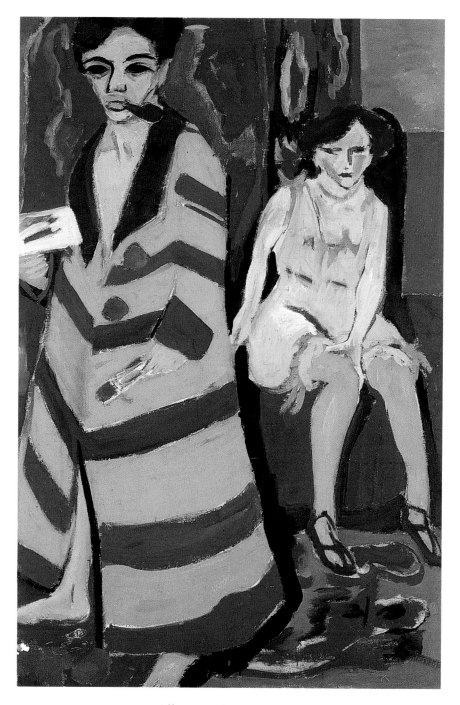

Self-Portrait with Model, 1910/1926
Oil on canvas, 150.4 x 100 cm
Hamburg, Hamburger Kunsthalle

The artist's mistress, seated behind him on the bed, figures both as his muse and as an embodiment of
the art to which he devoted his life. As a 1910 pastel of the same motif in a private collection indicates,
the painting was originally more spontaneous and expressive in character.

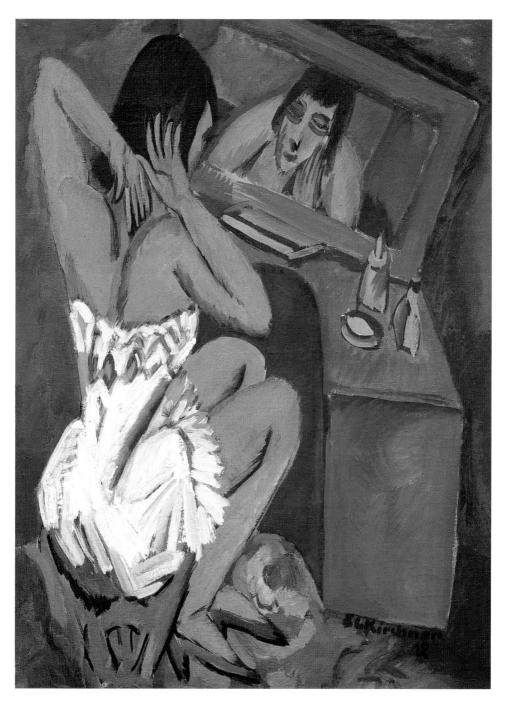

Toilette; Woman in front of a Mirror, 1913/1920
Oil on canvas, 101 x 75 cm
Paris, Musée National d'Art Moderne,
Centre Georges Pompidou

Kirchner later predated this painting to a year before
the actual execution of its initial phase.

proach. Occasionally Kirchner hesitated to take these later retouchings too far – as in *Toilette; Woman in front of a Mirror* (ill. p. 17), in which the elongated figure and nervous brushwork of 1913 were only slightly altered and toned down. In other cases, the reworkings were much more extensive. *Self-Portrait with Model*, for instance (ill. p. 16), was so to speak "homogenized" in 1926 by an addition of creamy colour gradations that lent the image a more rigorous, formalized character. The decorative, flat structuring and calm, considered, monumental composition favoured by Kirchner in the latter half of the 1920s, as in *Street Scene at Night*, 1926/27 (ill. p. 19), belied the cliché of the Faustian German Expressionist favoured by many later authors, who accordingly disqualified this phase as irrelevant, a dead-end.

Admittedly Kirchner himself used to flaunt this Faustian strain, as when he emphasized his great proneness to mental distress as a key motive force behind his work. But we must not accept everything he said at face value, because he loved mystifications. In the Davos diary he kept from 1919 to 1928, in his correspondence with friends and dealers, and in the essays he wrote on his own art, Kirchner continually launched distorted or false biographical data and legends. He had no qualms about predating his paintings with an eye to securing priority of stylistic invention. As his ideals he named Dürer, Rembrandt (1606–1669), and secondarily Gauguin and van Gogh, yet he denied any knowledge of the work of the Fauves and Matisse, just as he denied the influence of Munch. Kirchner used his intellectual copyright to put pressure on authors and even manipulate the scholarly record. Will Grohmann's monograph of 1926 was in large part dictated by the artist himself. When Carl Einstein requested permission to reproduce a painting for his 1926 volume on twentieth-century art in the Propyläen History of Art, Kirchner demanded an advance reading and revision of the text. Einstein refused, and the book was published without a Kirchner reproduction.

Was this mere self-aggrandizement? At any rate, his high opinion of himself markedly coloured Kirchner's verdicts on contemporary artists, whether the Fauves Matisse, André Derain (1880–1954), and Georges Rouault (1871–1958) or the Expressionists Oskar Kokoschka (1886–1980), Max Beckmann, and Erich Heckel. Today such statements are sometimes seen as clever self-advertising ploys. Yet the truth, as so often with Kirchner, is not that simple. Recent reinterpretations that describe Kirchner as a modern, media-oriented artist run the risk, as Christian Saehrendt points out, "of overestimating the strategically cool and calculating element in his biography … It would seem equally misleading to interpret Kirchner's influence on critique and reception as a despairing attempt at self-therapy on the part of someone who was mentally ill."

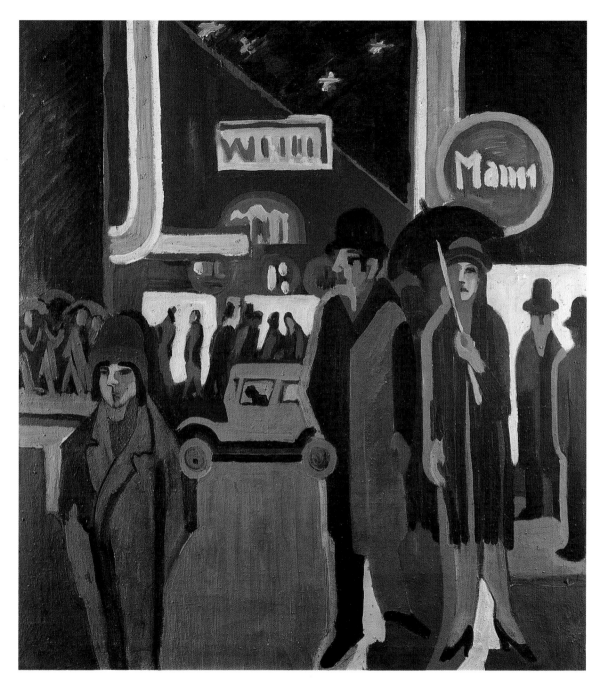

Street Scene at Night, 1926/27
Oil on canvas, 100 x 90 cm
Bremen, Kunsthalle Bremen

Before completion, this composition of sharply defined
colour areas arranged along horizontal and vertical axes
passed through three states, which Kirchner recorded
in photographs. Thanks to this procedure, a high degree
of visual organization was achieved.

A "plea for unrestraint"

Kirchner came of a good family, who expected him to adopt a "respectable" career. Ernst Ludwig Kirchner was born on May 6, 1880, in Aschaffenburg, Lower Franconia. His family – as he later never tired of emphasizing – could be traced back on his father's side to the sixteenth century. His father, Ernst, an engineer and chemist in the paper industry, and his mother, Elise, born into a business dynasty, had moved to his birthplace from Brandenburg. The Kirchner family tree included a learned Protestant pastor with an interest in history and prehistory, and who also figured in a great travel description of the day, Theodor Fontane's (1819–1898) *Wanderungen durch die Mark Brandenburg* (Walks through Brandenburg). His ancestors on his mother's side probably included Huguenots – possibly a reason why Kirchner, in 1919, invented a French military doctor in North Africa called Louis de Marsalle, under whose name he published a series of six essays that praised his paintings to the skies.

Already as a child, Kirchner showed signs of a vivid imagination and receptiveness to visual stimuli, but also of proneness to panic attacks. This hypersensitivity would remain with him for life. In 1887 the Kirchners moved from Frankfurt to peaceful Switzerland. For three years they lived near Lucerne, where his father served as vice-president of a paper company. In 1890 Ernst Kirchner received the first German professorship in paper research, at the Trades Academy in Chemnitz – entailing another move. Ernst Ludwig attended elementary and higher school in Chemnitz, and made his first essays in drawing. In a later letter he would recall, "In my early youth I already had regular drawing lessons, and for a time my father even hired an English watercolour teacher for me, despite the expense…"

His father, a talented draughtsman in his own right, must have been proud of his artistically gifted son. But a career in art – no, thank you. Nor was the profession of aviator exactly what he had envisioned for his son. In 1895, Ernst Kirchner went to Berlin to visit his boyhood friend, the famous engineer and aviation pioneer Otto Lilienthal, shortly before the latter crashed to his death. Highly impressed, young Ernst Ludwig toyed with the idea of becoming an aviator. He was even permitted to attempt a short flight himself. Yet his father categorically refused to let him continue the adventure. Both of Ernst Ludwig's career choices seemed too risky, that of a new Icarus as much of that of a new Matthias Grünewald, the renowned artist (c. 1475/80–1528) whose work the boy

Reclining Nude (Isabella), 1906
Charcoal on paper, 90 x 69 cm
Kassel, Staatliche Museen Kassel,
Graphische Sammlung

Isabella was one of the first of Kirchner's girlfriends to pose for him in the nude. In a diary entry for 1923, the artist recalled sometimes getting up in the midst of lovemaking to sketch his partner's spontaneous movements or facial expressions.

Exhibition poster of Die Brücke, 1910
Colour woodcut in black and red, 82.2 x 59 cm

had so admired at the Frankfurt Museum. So there was to be no nonsense. Ernst Ludwig would study architecture.

Reluctantly bowing to his parent's wish, he entered Dresden Technical College in the summer semester of 1901. After earning his preliminary diploma in 1903, Kirchner completed his unloved studies with a good degree in 1905. Now he was a graduate engineer, but at heart, he had long since become a painter.

Interrupting his architecture studies in 1903–04 to spend a semester in Munich, Kirchner devoted himself entirely to art, taking courses in modelling, life drawing, and anatomy at the Academy and attending a private art school run by Wilhelm von Debschitz (1871–1948) and Hermann Obrist (1862–1927). Here he learned the woodcut technique and experimented with the potentials of Art Nouveau. During visits to museums Kirchner was especially impressed by the drawings of Dürer and Rembrandt. The expressive attack, lineature reduced to essentials, no overly detailed interior hatching, and the balance of halftones and darks seen in Kirchner's charcoal drawing *Reclining Nude (Isabella)*, 1906 (ill. p. 21), clearly recall Rembrandt's prints.

In 1905 Kirchner jettisoned all his family's plans for a solid middle-class life and career in architecture. On June 7 of that year, three weeks prior to his final examination, he became co-founder of an artists' group in Dresden. They called themselves Die Brücke, in allusion to a metaphor in Friedrich Nietzsche's *Thus Spake Zarathustra* (1883–1885): "What is great in Man is that he is a bridge and not a goal; what is lovable in Man is that he is an over-going and an under-going …" From then on Kirchner's relationship with his parents was troubled. He had to overcome his reluctance to visit them occasionally in Chemnitz, because he needed their financial support. Apparently it was only rarely granted to him.

The founding members of Die Brücke, apart from Kirchner, were Fritz Bleyl (1880–1960) from Zwickau, Erich Heckel from Chemnitz, and Karl Schmidt from Rottluff near Chemnitz, who adopted the pseudonym Schmidt-Rottluff (1884–1976). Like Bleyl, who left the group after only two years and later became a teacher, and like Kirchner, Heckel and Schmidt-Rottluff had studied architecture in Dresden – all of them merely to please their parents.

Now, in 1905, they began to think of themselves as a chosen elite who set out to make "elbow room and free lives" for themselves "in face of the established, older forces", as they declared in the Brücke manifesto. Since this seemed impossible in the bourgeois milieu from which they came, they moved to a working-class district of Dresden, Friedrichstadt. Heckel had rented a former butcher's shop on Berliner Strasse there, which Kirchner took over as his studio in 1906. Karl Schmidt-Rottluff had lived in the building, two flights up, for a year now.

The young artists launched into tobacco-steeped debates on art, philosophy and current events. They also worked obsessively, in Kirchner's storefront or Heckel's studio in an empty shoemaker's shop down the street. Sometimes they would get up in the middle of the night to capture an idea in a sketch. As the manifestoes and activities of these "young savages" indicate, they viewed themselves not only as an association of artists but as a dedicated living commune, along the lines of their idols of the Romantic era. Yet they were also very practically minded, knowing the importance of effective publicity in the form of group exhibitions and joint publications. The four artists shared everything, from studios and models (cf. ill. p. 22) down to painting materials, partly out

Rembrandt
Christ and the Adulteress, c. 1656
Pen and ink with bister, 17 x 20.2 cm
Munich, Staatliche Graphische Sammlung

Erich Heckel and Model in the Studio, 1905
Oil on cardboard, 50 x 33.6 cm
Berlin, Brücke-Museum

This picture was evidently done during a session in which several artists painted from the same model. One of their easels is visible in the left foreground. Heckel works at the right, his arm cut off by the edge of the panel.

of a lack of funds but primarily out of their idealistic notion of a fraternal community of labor. Due to this symbiosis, the early styles of the Brücke painters were almost indistinguishable. A new vision and a new approach began to take on collective shape, and over the next decades the German Expressionism developed on its basis would achieve Europe-wide renown.

In 1906 the founders of Die Brücke were joined by Max Pechstein (1881–1955), who attended the Dresden Academy after an apprenticeship in decorative painting, and Emil Nolde (1867–1956), who, however, left the group after only a year and a half because he felt hemmed in by their rules and rituals. In 1910 Otto Mueller (1874–1930) became a member.

The Brücke manifesto of 1906 was not so much a statement of clear guidelines as an appeal to all progressive artists and thinkers to join together and launch a revolution in art and life. They took this goal absolutely seriously, for as Pechstein proclaimed, "Art is not a pastime, it is a duty with respect to the people, a public affair." The appeal was too passionate, indeed missionary, for the artists to be satisfied with local effects, and from the very start they carried it beyond Germany's borders. They were able to convince the Swiss artist Cuno Amiet (1868–1961) and, at least nominally, Axel Gallén-Kallela (1865–1931) of Finland. In 1908 Kees van Dongen (1877–1968), a Dutch Fauvist, joined as honorary member for a year. Edvard Munch, despite repeated advances and invitations, declined to become an active member. But he was one of what the group called passive members – friends and supporters of Die Brücke. In return for an annual donation the passive members received an annual portfolio of original etchings, lithographs and woodcuts by Brücke artists, a beautifully designed membership card, and the annual report, which likewise included original prints. Today these annual portfolios are among the rarest and most highly sought-after documents of early Expressionism. From 1909 onwards they were each devoted to the work of a single painter. The cover of the Schmidt-Rottluff portfolio featured a woodcut by Kirchner.

From the beginning, Die Brücke plunged into frenzied activity, mounting no less than seventy recorded group exhibitions between 1905 and 1913. Their first projects were as unusual and provoking as they were unsuccessful. Heckel gained the interest of a manufacturer of lighting fixtures, Karl-Max Seifert. In 1906 Seifert's factory in the Dresden district of Löbtau hosted a show of the group's recent paintings and prints, which must have looked surreally out of place among the ceiling lamps.

The next show, in September 1907, was held in a real gallery, Kunstsalon Emil Richter on Prager Strasse. One reviewer, Ernst Köhler-Haussen, enthused that this astonishing imagery was a "product of surging ferment," a "plea for unrestraint, a yearning desire for what lies beyond the previously permitted, beyond what has been possible in art until now." The young art critic then visited Kirchner in his studio. "I found pictures there, colourful and patchy like nothing I had ever seen, even in the most daring of French Impressionists," he reported. "I particularly like the originality and independence of Kirchner … I am going to give my wife a Kirchner portrait woodcut for Christmas. And I plan to become a 'passive member'." The next high point came in 1910, with an exhibition at Galerie Arnold on Schlossstrasse, the best address for modern art in Dresden at that period, and the venue of the show of foreign art that had pointed Kirchner and Die Brücke along the road they were to take.

Köhler-Haussen, who probably had no broad insight into the international art scene, credited the young Kirchner with having entered completely uncharted

Karl Schmidt-Rottluff
Village House with Willows, 1907
Oil on canvas, 85 x 75 cm
Berlin, Staatliche Museen zu Berlin –
Preussischer Kulturbesitz, Nationalgalerie

Green House, 1907
Oil on canvas, 70 x 59 cm
Vienna, Museum Moderner Kunst Stiftung Ludwig

This motif was reputedly painted in the village of Goppeln, south
of Dresden, where Kirchner and Pechstein stayed in summer 1907.

territory. In retrospect, this claim appears exaggerated. Consider a small oil of 1905, depicting *Erich Heckel and Model in the Studio* (ill. p. 22). It clearly shows Kirchner's indebtedness at that period to Post-Impressionism, which he had seen for the first time in Munich. Another link between Die Brücke and the Parisian avant-garde was established by Cuno Amiet, who was half a generation older than Kirchner. In 1904, the Swiss artist had begun to separate his luminous colour areas with heavy, expressive contours that tied the subject solidly into the background. Amiet had seen contouring of this kind in the 1880s and '90s in Paris, in the work of the Nabis, especially Maurice Denis (1870–1943), Pierre Bonnard (1867–1947), and Edouard Vuillard (1868–1940). Kirchner's studio picture, too, is fundamentally based on these abstracting principles, and an employment of pure, unmixed colours and the emotional force they convey. This is underscored by a comparison with a work of Bonnard's, *At the Circus*, painted in 1900.

The next impulse came again from Galerie Arnold, which in 1905 mounted the first presentation in Germany of the work of van Gogh. His compellingly expressive paintings made a deep impression on Kirchner, as seen in *Green House*, 1907 (ill. p. 25). Here a Post-Impressionist colour separation by means of regularly placed dabs of paint was superseded by vehement strokes à la van

Houses on Fehmarn, 1908
Oil on canvas, 75 x 98 cm
Frankfurt am Main, Städelsches Kunstinstitut, on loan from private collection

Gogh. Dynamic vitality supplanted the grace of line and was still present in the oil of the 1905 studio scene (ill. p. 22). Van Gogh's influence was especially strong on Schmidt-Rottluff (ill. p. 24), and Heckel, too, lay on the same wavelength. As the Brücke artists collectively took up the challenge of van Gogh, the appearance of their works grew increasingly similar.

Kirchner stood outside this collective style to the extent that he worked always at the highest pitch and tirelessly sought new solutions. In the early years of Die Brücke he absorbed every stimulus that seemed promising and unconventional enough to bear fruit. His *Houses on Fehmarn*, painted in 1908 (ill. p. 26), for instance, has a strongly agitated yet heavy paint application, partly done with a palette knife, that indicates the declining influence of Post-Impressionism in favour of van Gogh between 1907 and 1908. On the other hand, the blue and red pencils used in drawings such as *Two Seated Nudes* (ill. p. 36) went back to the Viennese Jugendstil artist Gustav Klimt (1862–1918), whose works Kirchner saw in a 1907 exhibition of Austrian art in Dresden. And the painting *Street* of 1908 (ill. p. 29), despite its revision in 1919, clearly indicates the debt Kirchner owed to Munch (ill. p. 28): figures approaching the viewer across an expansive pictorial stage; bright, occasionally blatant colours; and heavy contours that hold the simplified motifs together and tie them into a flat pattern. That Kirch-

Landscape in Spring, 1909
Oil on canvas, 70.3 x 90.3 cm
Kaiserslautern, Pfalzgalerie

Done in spring 1909, this was the first of Kirchner's pictures to reflect a definite Fauvist influence. It was on view in the 1909 Brücke exhibition at Kunstsalon Emil Richter in Dresden. Kirchner later predated it to the year 1904.

ner intended this picture as a chef-d'œuvre is indicated by the large format. It was his earliest street scene, a subject that would later inspire some of his greatest achievements.

Perhaps the most crucial stimulus from Parisian art came with the spectacular Matisse retrospective held at Galerie Cassirer in Berlin. This first solo show of the artist's in Germany was on view from December 1908 to January 1909. Now, throughout his life Kirchner denied ever having seen the work of the leader of Fauvism, and around 1925, he denigrated his erstwhile friend Pechstein by calling him a "shameless Matisse imitator". Yet in making this denial he apparently forgot the postcard he sent from Berlin to Heckel in Dresden on January 12, 1909 (now in the Altonaer Museum, Hamburg). Signed by both Kirchner and Pechstein, it translates: "Best regards, Ernst; Matisse in part very wild; regards, Max." Moreover, according to some of the artist's acquaintances, at this Berlin exhibition Kirchner suggested recruiting Matisse as a member of Die Brücke. However, no contact in this regard was apparently made.

The Fauves' style might be briefly characterized as rich in colour applied in expansive fields, with the subject matter abstracted and reduced to essentials. Generally the coloration, composed of unmixed hues, is of extreme intensity. The colours are no longer bound to the task of a naturalistic description of things and therefore are capable of developing an enormous power of expression. The fascination exerted on the Fauves by the art of Africa and the South Pacific encouraged them in pursuing their aim of engendering decorative effects by means of extreme (if deceptive) simplicity.

Decorative art! In Germany at that time, the term bore a largely negative connotation, as of something "merely" pleasing to the eye. This is why the supposedly Faustian Kirchner was frequently imputed to have had no interest in the decorative aspects of Matisse's art. This was entirely mistaken. Quite the contrary, of all the Brücke members, his interest was deepest. Emphasis on the arrangement of colour fields was one of his prime concerns, and it was further encouraged by a study of late-Gothic woodcuts. Even Kirchner's subsequent turn to sharp, angular forms and a "brutalized" colouration passed through this Fauvist school of calculated equilibrium, subtle audacity, and balance between sensation and formal articulation. The controlled enthusiasm of these works would have been unthinkable in the absence of its opposite pole, a considered analysis of the form-colour interplay. *Landscape in Spring*, 1909 (ill. p. 27), with its free yet masterfully controlled treatment of colour and colour fields, is a veritable exercise on influences from Matisse and the Parisian Fauves. Like the oil of the same date, *Girl under a Japanese Parasol* (ill. p. 31), it employs a loose, watercolour-like approach that was then deemed unacceptable in Germany, a flowing brushwork that supplanted thick impasto in the wake of brilliant French colorism. Realistic evocation of space, perspective, proportion no longer played the slightest role. Many other examples of Kirchner's work of this period could be cited in evidence of this fundamentally Fauvist approach.

Like all the Brücke painters, Kirchner had no intention of painting pictures to adorn the living room. "Instead," as Lothar-Günther Buchheim put it, "with all the exuberance, fire and passion of youth, they wanted to apply an unspoilt sensibility to open up to art buried sources of elemental feeling, without concessions to contemporary taste, and without visual prejudice." Kirchner sought such elemental feeling when he settled in the working-class district of Dresden-Friedrichstadt, hoping that mingling with ordinary, supposedly unspoiled people would help him find it. The aim of his existence, as of his work in the studio, was

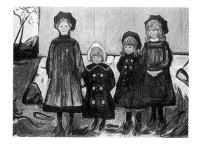

Edvard Munch
Four Girls in Asgårdstrand, 1904/05
Oil on canvas, 87 x 111 cm
Oslo, Munch-Museet

a sensuous harmony of life and art. This basically idealistic goal was reflected in his depictions of Dresden, portraits of friends, and above all, time and again, in his many drawings and paintings of nudes (ills. pp. 9, 21).

As we said, people felt free to move around in unashamed nakedness in Kirchner's studio (ill. p. 92). This had to do with sexual freedom, but it also and principally served the purpose Kirchner noted in a 1927 diary entry: "Art is made by human beings. Their own figure is the centre of all art, because its form and proportions are the basis and point of departure for every sensation … This is why my foremost demand is that every art school have drawing from life as a basic course." He placed great store in having his models pose naturally. And that for no more than ten or fifteen minutes at a time, until stiffness began to creep in. Kirchner and his fellow artists used to change places frequently. This spontaneous change of vantage point and their rapid working methods encouraged an almost automatic approach to drawing and a summary painting style which trained the eye for the essentials of form (cf. ill. p. 22).

Kirchner often relied on a long rectangular mirror that hung on the wall of the Dresden studio to help him further simplify his motifs, as in the painting *Reclining Nude with Pipe* (ill. p. 30). It shows the artist's girlfriend, Dodo, who was four years his junior. Clad only in pink slippers, she lies on her stomach on

Street, 1908/1919
Oil on canvas, 150.5 x 200.4 cm
New York, The Museum of Modern Art

By employing an extremely large format, Kirchner again and again marked individual paintings as major works which shed instructive light on his particular intentions. This street scene, the first in the series on this subject, is a case in point.

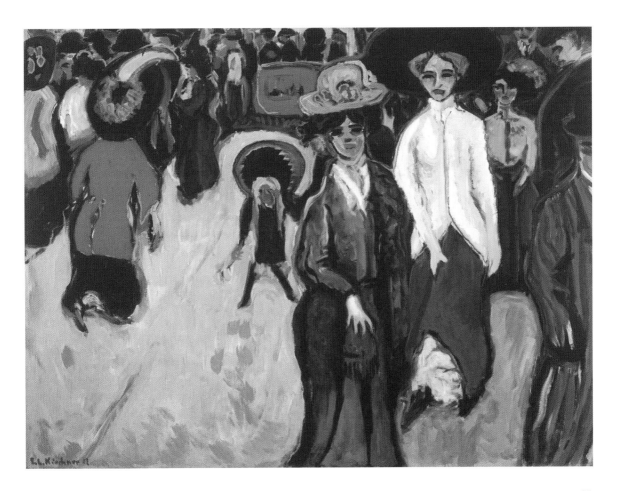

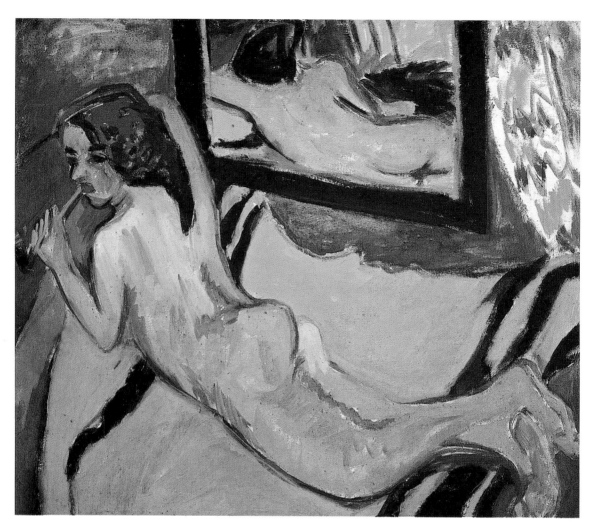

Reclining Nude with Pipe, 1909/10
Oil on canvas, 83.3 x 95.5 cm
Berlin, Brücke-Museum

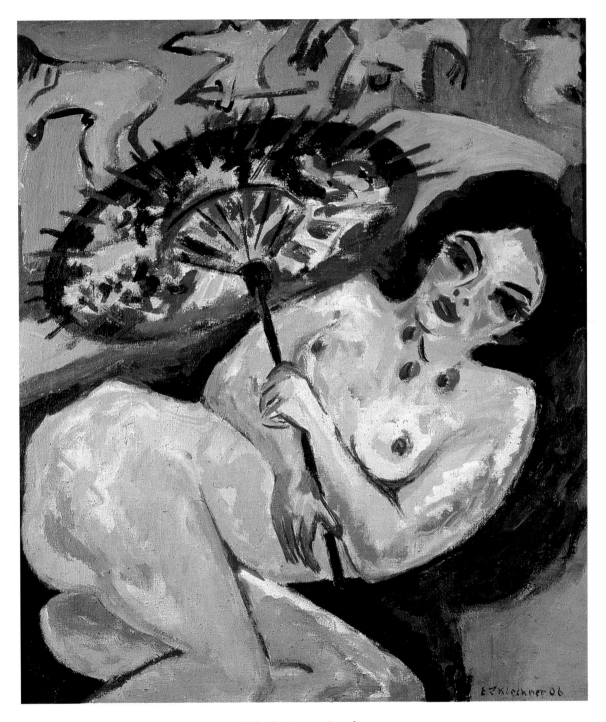

Girl under a Japanese Parasol, 1909
Oil on canvas, 92 x 80 cm
Düsseldorf, K20 Kunstsammlung Nordrhein-Westfalen

Bathers in a Room, 1909/1920
Oil on canvas, 151 x 198 cm
Saarbrücken, Saarland Museum,
Stiftung Saarländischer Kulturbesitz

The suggestion of a male figure at the far right
edge, almost completely expunged when Kirch-
ner reworked the painting in 1920, presumably
represents the artist. He also toned down the
erotic emphasis of the painting, which was
originally titled *Bacchanal in a Room.*

PAGE 34:
Fränzi in Carved Chair, 1910
Oil on canvas, 70.5 x 50 cm
Madrid, Museo Thyssen-Bornemisza

PAGE 35 TOP:
Nudes Playing under a Tree, 1910
Oil on canvas, 77 x 89 cm
Munich, Pinakothek der Moderne

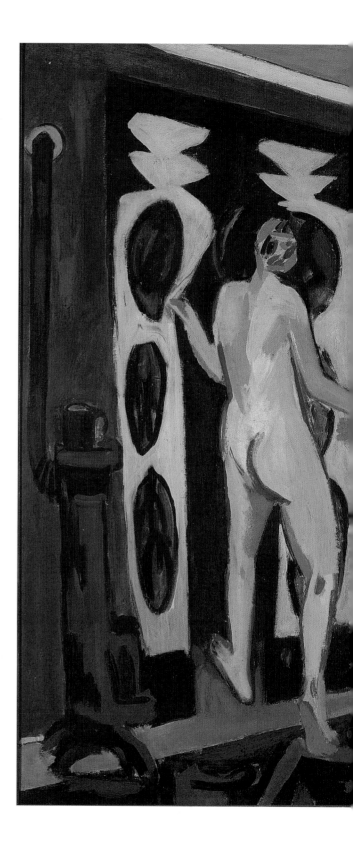

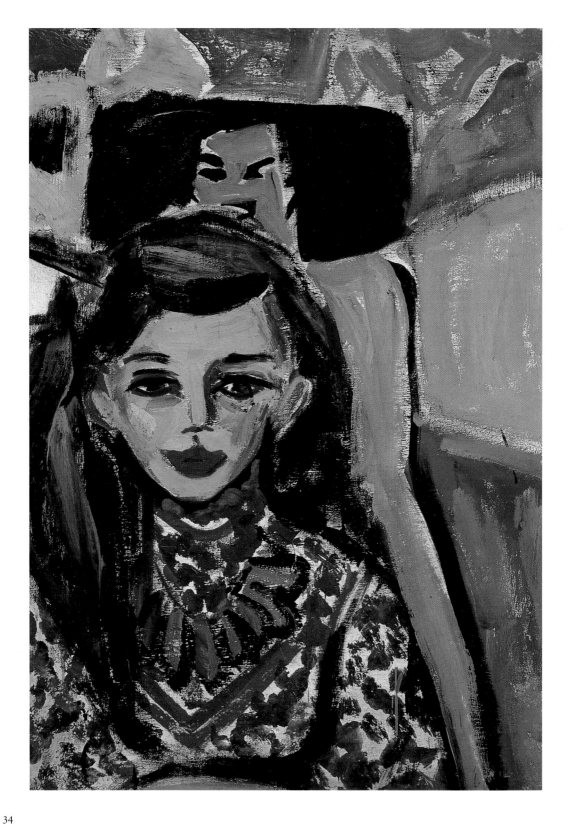

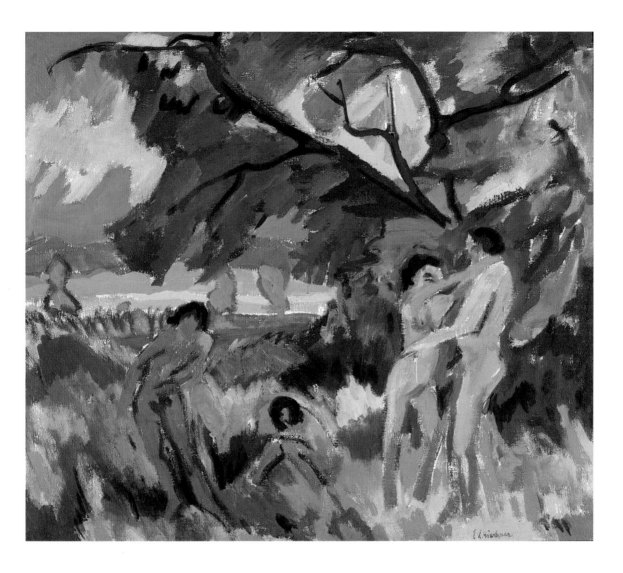

Max Pechstein
Bathers in Moritzburg, 1910
Oil on canvas, 70 x 79.5 cm
Duisburg, Wilhelm Lehmbruck Museum

a sofa, smoking a long-stemmed pipe. Doris "Dodo" Grosse lost her parents at an early age and lived with various of her siblings. She was apparently a milliner by profession. The mirror frame concentrates our attention on the elemental fact of the human body, showing it both as part of nature and as illusion. The nude figure enters a symbiosis with its reflection in the mirror, a symbiosis in which – as in many renowned earlier works of art – the potentials of a depiction combining natural appearances and imagination are explored. In addition, the use of a mirror to simultaneously depict two different points of view corresponded to Kirchner's growing interest in sculpture and carved figures, a topic to which we will return below (cf. pp. 55f.)

The winter of 1909–10 marked the emergence of an early masterpiece on the subject of the "free nude", the oil *Bathers in a Room* (ill. pp. 32/33). The "bathers" are nude female figures gambolling through an interior furnished with painted wall hangings and curtains in magnificent colours. The fragmentarily visible male

Page 37:
Artiste; Marcella, 1910
Oil on canvas, 100 x 76 cm
Berlin, Brücke-Museum

This picture was apparently done at an inn or
pension during the artist's stay in Moritzburg in
1910. Presented in 1914 to his friend and patron,
the archaeologist Botho Graef of Jena, it bears
the title *Artistin* on the back in Kirchner's own
hand.

Two Seated Nudes, 1907/08
Coloured pencils on paper, 34.5 x 44 cm
Karlsruhe, Staatliche Kunsthalle

figure at the right – probably the artist himself – has almost entirely vanished
under new paint layers applied in 1920. The curtain in front of the passage into
a second room is adorned with depictions of couples and a king in a crouching
position. Visible through an open door into another room is a nude woman on
a bed.

At the beginning of the year 1910, Heckel had met two adolescent sisters by
the name of Marcella and Fränzi, said to be the daughters of the widow of an
artiste who lived in Kirchner's neighbourhood. For a year the two girls were inte-
grated in the life of Die Brücke, and the artists' relationships with them, as with
many another young teenage girl in the studio, were probably more than platonic.
Thanks to their carefree charm, Marcella and Fränzi became favourite models,
whether in the nude (ill. p. 15) or dressed (ill. p. 34). One portrait, presumably
representing the fifteen-year-old Marcella, became one of Kirchner's most com-
pelling paintings (ill. p. 37).

The composition is marked by intrinsic monumentality and clarity. The girl's
pose is very casual, one knee raised, her head resting on her right hand. A relaxed,
introverted mood, underscored by the cat asleep in the foreground, pervades the
scene. Wine bottles in the background contribute to the bohemian atmosphere.
The simplicity of the composition is deceptive, for its structure is extremely
refined. The motifs are arranged along a rising diagonal from lower left to upper
right. Smooth, homogeneously opaque colour fields limited to a few intense
hues, including a dominant green, and closed contours establish a composi-
tional rhythm.

The brilliance of Kirchner's treatment is underscored by a comparison with
Pechstein's portrait of Marcella, likewise done in 1910. It was no coincidence that
Kirchner chose the unusual vantage point from which the model is depicted di-
agonally from above. This high vantage point brings the girl close to the viewer;
yet at the same time it shows her turning away as if to escape from the voyeuris-
tic gaze.

Max Pechstein
Girl on a Green Sofa with a Cat, 1910
Oil on canvas, 96.5 x 96.5 cm
Cologne, Museum Ludwig

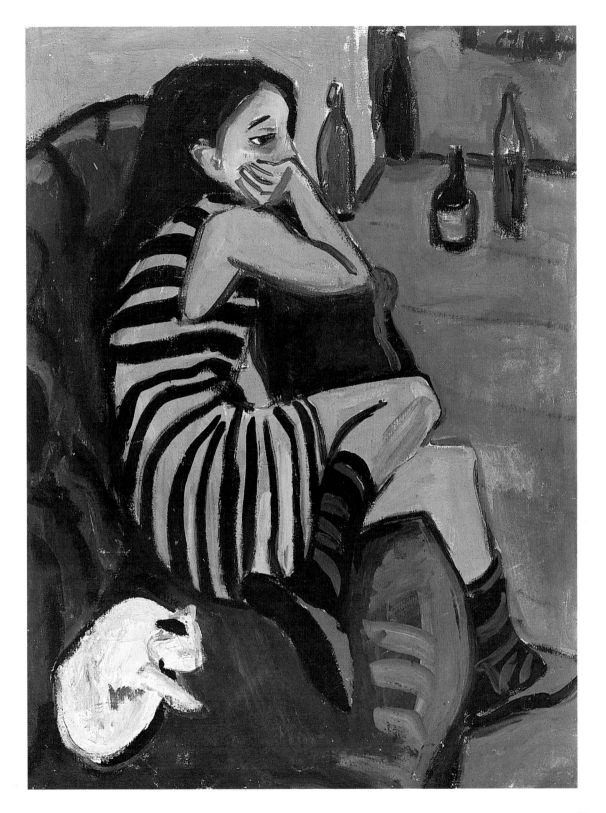

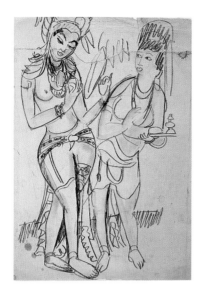

Master and Servant (after an Ajanta Fresco),
c. 1910/11
Pencil and coloured pencil on brownish paper,
47.5 x 33.7 cm
Berlin, Brücke-Museum

Lucas Cranach the Elder
Venus, 1532
Oil on wood, 37 x 25 cm
Frankfurt am Main, Städtische Galerie im
Städelschen Kunstinstitut

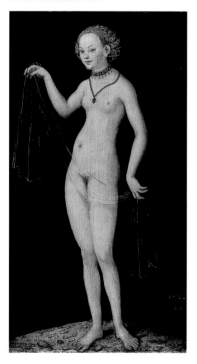

Marcella and Fränzi accompanied the Brücke painters on the summer excursions to the Moritzburg Lakes they began to take in 1909. Only Schmidt-Rottluff, being somewhat of a hermit, never came along. The lakes around Moritzburg Castle outside Dresden were a perfect place to escape the summer heat, and swimming in – and painting from – the nude were usually no problem. Not always, however. As Pechstein reported, the party was once surprised by a local gendarme who accused them of immoral behavior and confiscated one of Pechstein's pictures. Yet no charges were lodged, thanks to a letter of recommendation from their former academy teacher, Otto Gussmann. The artists and their models stayed at country inns and tried to live in accordance with the basically Romantic ideal of regaining all that was natural in life and art, and to enhance relations between the sexes by what Kirchner called a "Zweieinheit", or "two-in-oneness". The influences, and inhibitions, of civilization were to be left behind.

When we consider that back then a labourer had to work eleven-and-a-half hours a day, six days a week, to secure a minimum existence, had an unpaid vacation of at most two or three days a year, and that living conditions in the tenements were appalling, we can understand why the Brücke artists' escape to the Moritzburg Lakes must have seemed like an anticipation of paradise on earth. It was surely no coincidence that their collective style reached its culmination at that period (ill. p. 35).

Another contributing factor was their shared enthusiasm for the art of the South Pacific and African sculpture, which they admired and studied at the Dresden Museum of Ethnology. The heavy black contours, angular physiques, masklike faces and vivid poses of the figures in their paintings derived in part from these sources. The Gauguin exhibition held in 1910 at Galerie Arnold in Dresden, for which Kirchner designed the poster based on a Gauguin painting of a Tahitian beauty, provided further impetus for a concern with the perception and art of cultures beyond the European orbit.

Yet Kirchner's love of experiment was too strong for him to be satisfied with admiring exotic works like the carved and painted wooden beams from the South Pacific island of Palau in the Museum of Ethnology. Nor did he ever attempt to adopt the magical or religious meaning of such art. The often-quoted "primitivism" of the German Expressionists represented only one impulse among many for Kirchner. It played no role at all in one of his most significant paintings, indeed one of the landmarks of German modernism, *Standing Nude with Hat* (ill. p. 39). The model for this upright format was, once again, Dodo, the most important woman in Kirchner's life from 1908 to 1911. There is a moving description of her on the first page of his Davos journal, written in 1919: "You, Dodo, with your diligent hands. Still and fine and so palely beautiful. Your fine, free lust for love, with you I experience it to the full, almost at the risk of my destiny. Yet you gave me the power of speaking about your beauty in the purest image of a woman, compared with which Cranach's Venus is an old crone."

The figure, nude except for an elegant hat, stands lifesize in the studio, in front of a curtain decorated by the artist and a door through which a divan and erotic paintings are visible. The composition, as Kirchner so bluntly points out, was modelled on the 1532 *Venus* by Lucas Cranach the Elder. A reproduction of this work hung in Kirchner's studio. In other words, he admitted that the German Renaissance tradition was one source of his art – and at the same time proved that such reminiscences did not merely issue in an effusiveness of line or untrammelled expressiveness. In fact, the key feature of this masterly nude is its formal control, that exquisite arrangement of fields and masterful handling

of luminous colour fields which Kirchner had carefully observed in the Fauves and Matisse.

Another masterwork is *Five Bathers by a Lake* (ill. pp. 40/41), completed in 1911. Leafing through an archaeological book, Kirchner had come across illustrations of Buddhist murals in the Indian cave temples of Ajanta, northeast of Aurangabad. "These works made me almost helpless with delight. This incredible uniqueness of depiction allied with a monumental serenity of form was something I thought I could never achieve; all of my attempts seemed hollow and unsettled. I copied many features of these images, just in an attempt to arrive at my own style," Kirchner later reported in his diary. His copying concentrated on paintings in the elegant style of the fifth and sixth-century Gupta period (ill. p. 38). He was reacting to a truly classical art that had arrived at perfection of expression. The sensuality of the female figures was reflected in the plasticity of their bodies, full breasts and thighs, broad hips, graceful gestures. In the artist's own words, they "are all surface and yet absolutely bodies, and thus have completely solved the mystery of painting."

Kirchner managed to translate this seemingly so simple solution into the terms of his own formal idiom. With his turn to Ajanta art, his interest in the flat Fauvist style logically decreased, and he began to devote undivided attention to depth, plasticity, and more subdued colours. By mastering these principles of design, in *Five Bathers* Kirchner achieved a virtually classical balance between two and three dimensionality that rivalled that of Cézanne's superb *Bathers*, which likewise aimed at giving form to an earthly paradise of equilibrium and harmony between man and nature (ill. p. 40). Kirchner's visit in November 1909 to the magnificent Cézanne exhibition at Cassirer in Berlin, where he sketched many specimens, had paid off. As Lucius Grisebach noted, the Expressionist revolutionary "who appeared on the scene claiming to leave traditions behind" nonetheless continually glanced back at art history and as it were "struck attitudes before it."

The year 1911 brought profound changes in the circumstances of Kirchner's life. These were paralleled by a stylistic change in the direction of agitated zigzag brushwork and vehement coloration. Yet the use of hatching along the contours and shading that gave the impression of three dimensions, inspired by Ajanta art, were to remain.

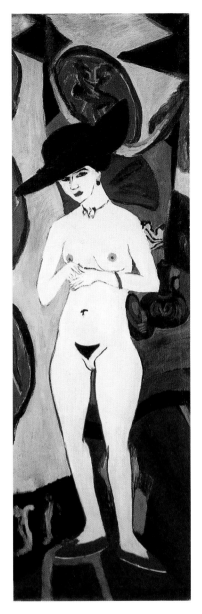

Standing Nude with Hat, 1910/1920
Oil on canvas, 205 x 65 cm
Frankfurt am Main, Städtische Galerie im Städelschen Kunstinstitut

Kirchner repeatedly described this nude of his girlfriend, Dodo, as one of his major works, which reflected the ideal of female beauty he held at that time.

Five Bathers by a Lake, 1911
Oil on canvas, 151 x 197 cm
Berlin, Brücke-Museum

The style of this painting was greatly influenced
by illustrations Kirchner had seen in a book
by the British archaeologist John Griffith, *The
Paintings in the Buddhist Cave-Temples of Ajanta*,
1896/97.

Paul Cézanne
Bathers, c. 1895–1904
Oil on canvas, 127.2 x 196.1 cm
London, The National Gallery

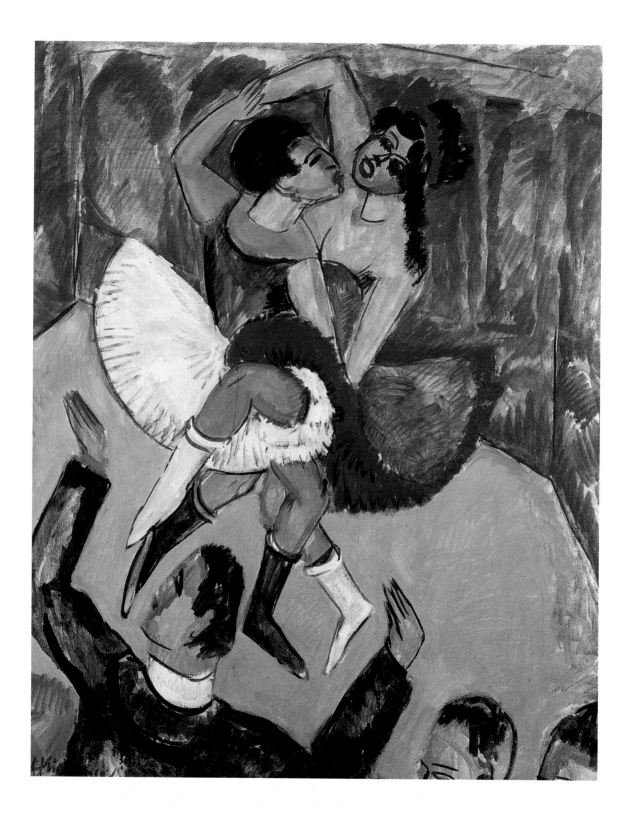

"Dance on the volcano"

In 1911 Kirchner left Dresden. The city where he matured into the major Brücke Expressionist, its galleries and exhibitions, its environs with the Moritzburg Lakes, his circle of friends and fellow-artists, had given him a great deal. Yet now he wanted to face a new challenge, the the hustle and bustle of a modern metropolis. In late September 1911 Kirchner wrote that he would go to Paris, the mecca of the avant-garde. A surprising statement in view of his outspoken aversion to French art. The plan, if he had seriously considered it all, was rapidly abandoned. Berlin was closer.

Pechstein had already established a foothold in Berlin in 1908, where as seismographer of Die Brücke he had been registering the artistic tremors in the imperial capital. The others visited him with increasing frequency. When Kirchner arrived there once more in January 1911, Pechstein introduced him to Herwarth Walden, founder of the Berlin gallery "Der Sturm" – one of Germany's most progressive art dealer – and editor of the eponymous revolutionary journal (inaugurated 1910). Shortly thereafter Kirchner's drawing *Panama Girls* appeared in its pages, followed by ten further original prints (to June 1912). The editors of *Der Sturm* included Oskar Kokoschka, the Viennese Expressionist (1886–1980). Like the other Brücke artists, Kirchner now came into contact with literary Expressionism: the *Sturm* circle around Walden and the radically anti-bourgeois circle around Franz Pfemfert and his journal *Die Aktion*, established in March 1911. As a result, the artists increasingly began to put their activities in the service of communicating a political and social message. A personal link between Kirchner and *Der Sturm* was forged by Alfred Döblin (1878–1957), a psychiatrist and author whose big-city novel, *Berlin Alexanderplatz*, would bring him fame in 1928. His novella *Das Stiftsfräulein und der Tod* (The Canoness and Death, 1913) was the first literary work Kirchner illustrated, contributing the cover design and four woodcuts. These were followed a short time later by three woodcuts to Döblin's one-act play *Komtess Mizzi*, a "bordello story", as Kirchner wrote. In 1912 he painted a penetrating portrait of Döblin. Artist and author maintained friendly ties until the early 1930s. Other Expressionist authors soon entered Kirchner's circle of acquaintances, including the poet Georg Heym, drowned in a skating accident in 1912, a volume of whose poems, *Umbra vitae*, Kirchner illustrated in 1924.

In the course of October 1911 Kirchner gave up his residence in Dresden and followed Pechstein and Mueller to Berlin. That December Heckel and Schmidt-

Portrait of Dr Alfred Döblin, 1912
Oil on canvas, 51 x 42 cm
Cambridge (MA), Courtesy of The Busch-Reisinger Harvard University Art Museums, Association Fund

Kirchner made ten drawings and a lithograph in preparation for this portrait, which wonderfully expresses the sensibility of the writer and psychiatrist.

Negro Dance, 1911
Oil on canvas, 151.5 x 120 cm
Düsseldorf, K20 Kunstsammlung Nordrhein-Westfalen

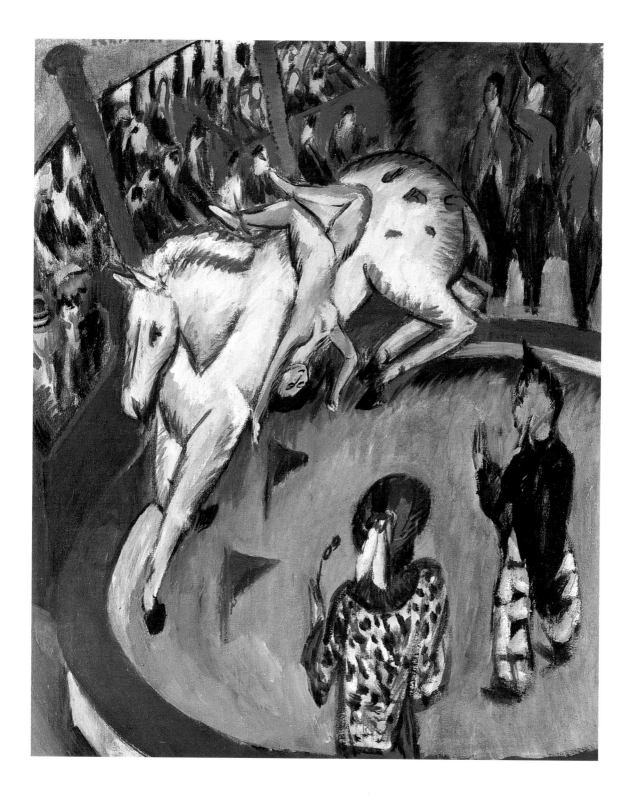

PAGE 44:
Girl Circus Rider, 1912
Oil on canvas, 120 x 100 cm
Munich, Pinakothek der Moderne

This painting is a major work on the circus
theme from Kirchner's Berlin period. Although
dependent in terms of composition on George
Seurat's *The Circus*, 1891 (Paris, Musée d'Orsay),
it far surpasses that work in expressive force.

Fehmarn Coast, 1913
Oil on canvas, 85.5 x 85.5 cm
Darmstadt, Hessisches Landesmuseum

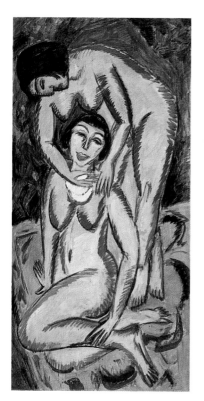

Two Female Nudes on a Vertical Format, 1911
Oil on canvas, 150.5 x 75.5 cm
Bern, Kunstmuseum Bern, Gift of Hilde Thann-
hauser from the Collection of Justin Thannhauser

Two Women with a Washbasin, 1913
Oil on canvas, 121 x 90.5 cm
Frankfurt am Main, Städtische Galerie im
Städelschen Kunstinstitut

The two women have been identified as Kirch-
ner's girlfriend Erna Schilling (in front) and her
sister Gerda (behind).

Rottluff arrived as well. The artists' individual moves were probably preceded by a common decision. The group displayed its true unity for one last time, in accepting the challenge to "dance on the volcano". This was the metaphor used in 1968 by the American art historian Donald E. Gordon to describe the expressive performances of Kirchner, whom he celebrated in his monograph as one of the greatest modern painters alongside Picasso.

At the start of the twentieth century, Berlin was the third-largest city in Europe, after London and Paris. It was a melting pot on the boil, where daring galleries and rebellious break-away movements, editors and publishers, dealers and collectors began to launch radical incursions into uncharted territory and openly oppose established Historical Revival art. All of this fascinated Kirchner, yet he viewed these goings-on, this dance on the volcano, with a mixture of love and hate: "It's terribly vulgar here. I see that a fine, free culture cannot be created in these circumstances and want to leave as soon as I have overcome this great slump." "Slump" was a mild euphemism for the lack of interest Kirchner's work had found in Berlin, and would find for as long as he lived there. The art reviews, if there were any at all, were negative, no representative one-man show came about, and the number of paintings sold was dismally small. A joint project undertaken with Pechstein, a school of drawing, also failed. Abbreviated MUIM, the school offered "modern instruction in painting, printmaking, sculpture, tapestry, glass and metal design. Painting in combination with architecture. Instruction with new means in a new way. Sketching from life … In the summertime, open-air life drawing by the lakeside…" read the now-famous woodcut poster designed by Kirchner. By autumn 1912 the modest institution, which had been under police observation, had to close its doors on account of insufficient attendance.

A glance at paintings such as Negro Dance (ill. p. 42) and *Two Female Nudes on a Vertical Format* reveals the new mode of structuring that Kirchner began to develop in 1911: an extremely versatile zigzag hatching, now broad and curving, now close-set and angular, which lent expression to the vibrato or staccato of the various stages of the painting process. At the same time, contour line attained to a peak of precision. From 1912 onwards – as seen in *Girl Circus Rider* (ill. p. 44) – the hatchings began to expand, often forcefully impinging upon the contours and occasionally even overlapping them. The increasing fury of Kirchner's attack and its vectors evoking visual dynamism may well have been influenced by Italian Futurism, which the artist saw and appreciated at the "Sturm" exhibition of April-May 1912. In addition, linking up with nineteenth-century French art, *Negro Dance* and *Girl Circus Rider* illustrate the popularity of subject matter from vaudeville, circus and dance among the Brücke artists. In Kirchner's eyes, these professions stood for the marginal groups and underdogs of the big city, for all those who, like artists, sold their souls to win the favour and money of the respectable citizenry. The exaltation of the dance and the daredevil feats of circus performers seemed fitting symbols for the "high-wire act" of the Expressionist artist who continually strained his creative powers to the breaking point.

The first six months of the year 1912 were rife with exhibition activities on the part of Die Brücke. The most sensational of these was an invitation to participate in an international show mounted by the "Sonderbund," or Special League of West German Art Friends and Artists, held in Cologne from May 25 to September 30. This event marked the acceptance of the Brücke artists into the European elite: their works hung alongside those of van Gogh, Cézanne, Gauguin,

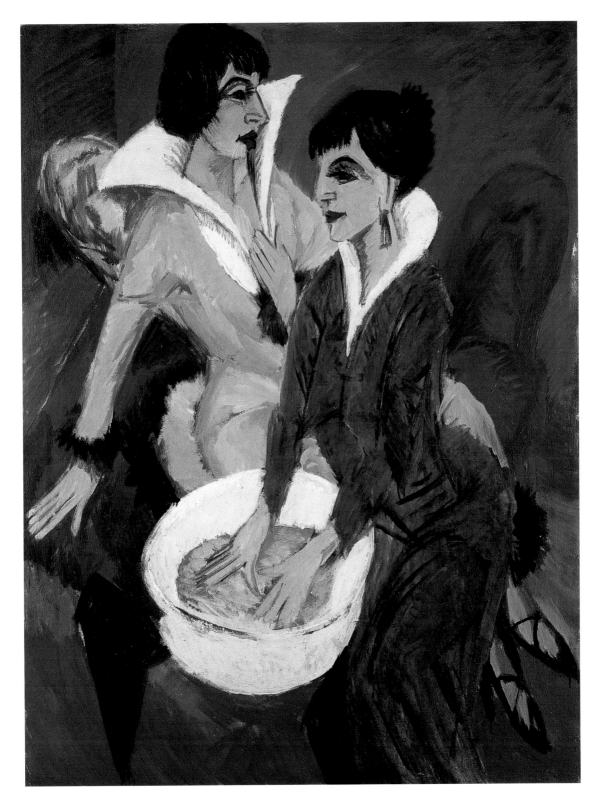

Signac, Munch, Picasso, Braque, Derain, Matisse, Vlaminck, Mondrian and Kokoschka. In a letter to his friend Jappe Nilssen, Munch reported, "The wildest things being painted in Europe are gathered here – I am nothing but a faded classic – Cologne Cathedral is quaking to its foundations." Heckel and Kirchner were invited to decorate the Sonderbund chapel. Kirchner painted a four-metre-tall madonna on burlap stretched across the apse – his sole religious work, only photographs of which have survived.

Kirchner considered leaving Berlin. Yet, as he noted, its "glue" held him fast. The only escape was a yearly vacation on the island of Fehmarn (ill. p. 45), which now became for him what the Moritzburg Lakes had been in his Dresden period. For Kirchner, an earthly paradise was unthinkable without women and models. In summer 1912, on the lookout for suitable female company, he met Erna and Gerda Schilling (ill. p. 47), two Berlin sisters who performed as nightclub dancers. Erna became his companion and remained with Kirchner until his suicide in 1938. Gerda, older and more worldly, later lost control of her life. She died of the consequences of syphilis, in 1924, in a psychiatric clinic in Neuruppin. Writing

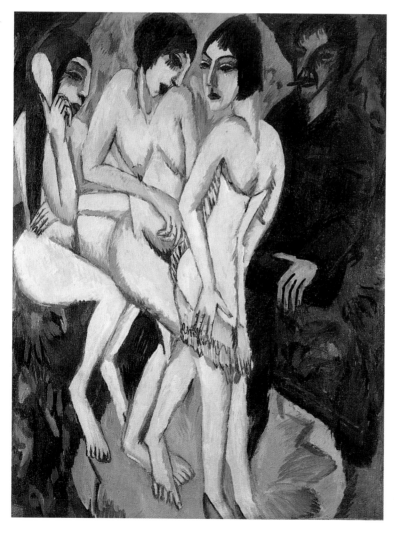

Judgement of Paris, 1913
Oil on canvas, 111.5 x 88,5 cm
Ludwigshafen, Wilhelm-Hack-Museum

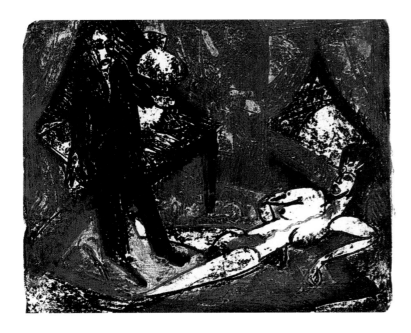

The Murderer, 1914
Colour lithograph in black and red,
50.4 x 59.7 cm
New York, The Museum of Modern Art

This is an illustration to a scene in Emile Zola's
novel *La Bête humaine.*

about the sisters, Kirchner later recalled, "The lovely, architecturally built, stringently formed bodies of these two girls supplanted the soft Saxon body. In thousands of drawings, prints and paintings these bodies formed my sense of beauty as I shaped the physically beautiful woman of our times."

Visual evidence of this process is found in the 1913 canvas *Judgement of Paris* (ill. p. 48). The story, from Greek mythology, tells of the son of a Trojan king, Paris, who is confronted with the goddesses Hera, Athena, and Aphrodite, and must decide which of them is most beautiful. In the painting Kirchner, smoking a cigarette, casts himself in this role, and the nude or semi-nude beauties bear the features of the Berlin sisters – in the foreground Erna, clad in a slip and averting her face.

From June 26 to September 5, 1912, Kirchner was on Fehmarn with Erna and Gerda for the second time. As before, they stayed in the house of the lighthouse keeper at Staberhuk, near the village of Burg on the southeast tip of the island (ill. p. 52). They spent carefree days on the beach beneath the cliffs, swimming, joking and painting (ill. p. 45). It was a prolific and harmonious time, as Kirchner later enthused: "Here I learned to represent the ultimate unity of man and nature … [and] painted pictures of absolute maturity … Ochre, blue, green are the colours of Fehmarn, wonderful coastal formations, sometimes of South Seas profusion…" The paintings of this period combine well-considered composition with a fluent, spontaneous, almost sketchy paint application, as in *Burg on Fehmarn,* 1912 (ill. p. 53), whose lucid structuring of sculptural volumes is reminiscent of Cézanne.

A cardinal work of this phase is *Figures Striding into the Sea* (ill. pp. 50/51), another large format. A nude woman and man are depicted walking into the surf beneath the steep shoreline and lighthouse, while a third woman lies on her stomach on the beach, sunning herself. The fluent, ornamental treatment of the figures evokes a carefree joie de vivre. A great rhythmic flow of energy runs through the composition from the lower left to the upper right. The almost exclusive use of secondary colours (green, violet, orange) still goes back to

Nude Combing her Hair, 1913
Oil on canvas, 125 x 90 cm
Berlin, Brücke-Museum

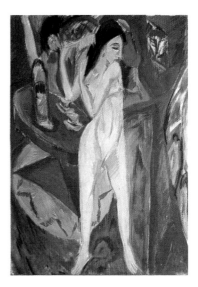

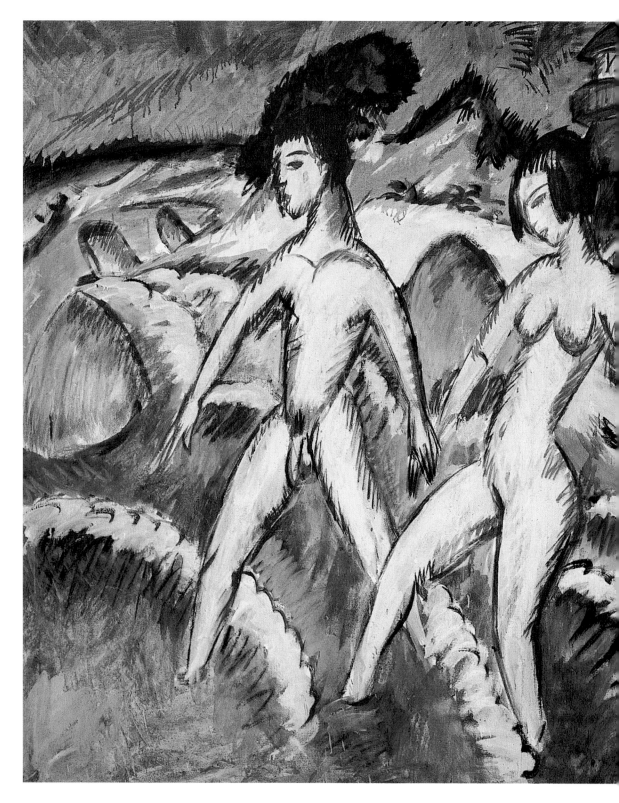

Figures Striding into the Sea, 1912
Oil on canvas, 146 x 200 cm
Stuttgart, Staatsgalerie Stuttgart

Ajanta art. The contour hatchings lend the figures, dunes and waves plasticity and simultaneously integrate the volumes into the flat articulation of the picture plane.

Fehmarn, that was "bliss" – Berlin, that was hectic pace, jostling crowds, noise. The nude human figure in the landscape reflected the ideal of natural harmony – the figure in the streets of the metropolis reflected human alienation. Still, in the latter half of the year 1912 Kirchner increasingly turned his untiring powers of observation to the headlong rush of big-city life. Its rhythm determined the rhythm of his compositions. He searched the turmoil for abbreviations, signs, "hieroglyphs," as he called them, and "his pencil turned into a hunter's rifle", as Karlheinz Gabler aptly noted. There emerged masterpieces like *Red Elisabeth Embankment, Berlin* (ill. p. 54), imagery that captured the quintessence of pulsating big-city life for all time. But the big city also meant streetwalkers offering themselves (ill. p. 7), the amusement industry (ills. pp. 42, 44), destruction (ill. p. 10) and violence (ill. p. 49).

Nude Viewed from the Back with Mirror and Man, 1912 (ill. p. 57), shows the extent to which such ambivalent impressions deprived even Kirchner's nudes of the innocence of the Dresden period. Instead of moving freely in familiar sur-

Staberhof Country Estate, Fehmarn I, 1913
Oil on canvas, 121 x 151 cm
Hamburg, Hamburger Kunsthalle

Staberhof Estate lies in the immediate vicinity of Staberhuk lighthouse on the island. Here its large barn in the Baroque style is depicted from the vantage point of the residence opposite.

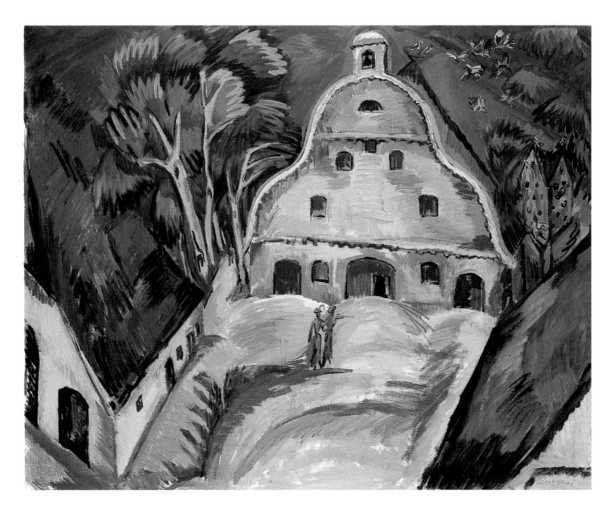

roundings, here the nude model is spirited into an artificial and harshly lit interior. An anonymous male figure looms as if threateningly in the background, a client before whose eyes the woman prostitutes herself, assuming a lascivious pose that is provocatively and narcistically doubled in the mirror. The colour gradations are no longer brilliant and bright but subdued; the brushwork nervous, with rapid hatchings that elicit a restless, charged atmosphere. This feeling is augmented by the vertically elongated figures that fill the upright format to the bursting point. Also, this composition anticipates another feature that would become a characteristic trait of Kirchner's pictorial scaffolding a year or two later, as in *Sick Woman; Woman with Hat* (ill. p. 56): a paint application whose close-set, fanning strokes recalled a bird's plumage, and an increasing accentuation of angular forms.

A similar hypersensitivity of the big-city dweller is found in the portrait of *Otto Mueller with Pipe* (ill. p. 58). Mueller, who joined Die Brücke in 1910, enjoyed an increasingly close friendship with Kirchner. In summer 1911 the two travelled together to Bohemia, and in summer 1913 Mueller and his wife Maschka

Burg on Fehmarn, 1912
Oil on canvas, 122 x 91 cm
Münster, Westfälisches Landesmuseum für
Kunst- und Kulturgeschichte

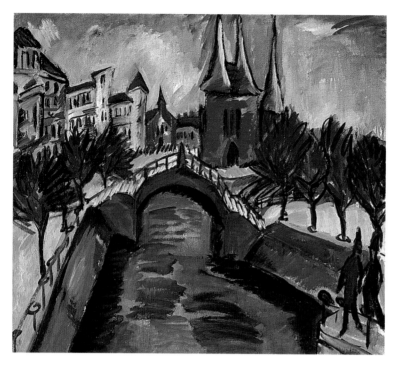

Red Elisabeth Embankment, Berlin, 1912
Oil on canvas, 101 x 113 cm
Munich, Pinakothek der Moderne

This picture records the view looking south over Luisen Canal, which has since been filled in. The prominent red-brick building is Melanchthon Church, destroyed in World War II, and behind it rises the spire of Neue Garnison Church, since renamed Church at Südstern, a main Berlin traffic intersection.

accompanied Kirchner on his Fehmarn holiday. This tie became all the more important for Kirchner when Die Brücke dissolved in 1913.

Pechstein had already been expelled from the group in 1912, because he had participated in an exhibition of the New Secession without his colleagues' agreement. On May 27, 1913, Die Brücke fell apart for good. It was Kirchner's fault. He had written a chronicle of the group in which he took credit for every innovative achievement they had made over the previous eight years. He had brought the woodcut technique from southern Germany, he stated, and also was the first to discover "Negro sculpture" and Oceanic carvings in the ethnographic museum, and so on. What was the reason for such boasting? Arrogance? An unhealthy egocentrism or a healthy self-confidence? The urge to give a long-since crumbling community the coup de grâce? Many factors likely played a role in prompting Kirchner's obfuscating statement. The others were naturally indignant, and boycotted the publication of the text. So Kirchner brought it out on his own, a step that virtually liquidated Die Brücke. In future he would deny ever having profited from being part of the group. It was not until 1926–27 that he painted a supposedly "reconciliating look back", *An Artists' Group* (ill. p. 59), a memorial to lost fellowship that meant more to Kirchner than he was ever prepared to admit. Yet typically, he could not resist depicting himself pointing to the chronicle of Die Brücke he had written and the others had rejected.

From 1913 onwards, then, Kirchner was on his own, responsible to no one but himself, but also unprotected, forced to face his fears and problems alone. His first one-man show took place in October of that year, not in Berlin, but in Hagen. It was organized by Karl Ernst Osthaus, founder and director of the Folkwang Museum. At that period Kirchner and Erna Schilling moved into a new studio-apartment, which occupied the entire attic floor of the building at 45 Körnerstrasse, Berlin-Steglitz. Many visitors were shocked at the poverty and

dinginess of the place, but they found its intense artistic aura exciting: The walls colourfully painted and adorned with Kirchner's works, batik curtains and embroideries by Erna based on the artist's designs, and homemade furniture brought over from Dresden. Objects from Africa and Asia, and Kirchner's own carved figures, rounded off the *Gesamtkunstwerk*.

Although painting remained his main concern, sculpture grew increasingly important to Kirchner fom 1909 onwards. "It helps me," he explained in 1914, "to translate spatial ideas into the large plane, just as earlier it helped me find the large, self-contained form." In other words, wood sculptures such as *Standing Female Figure*, 1912 (ill. p. 56), with its rounded torso, broad hips, and gestures that protect the body and contain its form, served primarily as experimental attempts to find formally expressive solutions that would ultimately benefit the artist's painting.

From February to March 1914 another large solo show was dedicated to Kirchner's work, this time in Thuringia, at the Jena Kunstverein. This art association, founded in 1903, was one of the most progressive of its kind in Germany. The show was initiated by Eberhard Grisebach, university professor of philosophy and head of the Kunstverein. This marked the beginning of a long and deepening friendship between Kirchner and the scholar, who admired the avantgarde and especially Expressionism. The lively historical town of Jena also brought

Belle-Alliance-Platz, Berlin, 1914
Oil on canvas, 96 x 85 cm
Berlin, Staatliche Museen zu Berlin –
Preussischer Kulturbesitz, Nationalgalerie

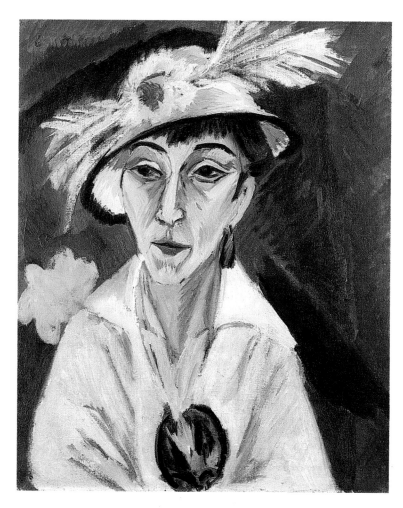

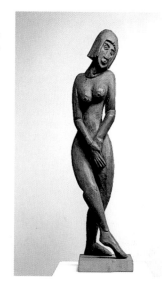

Kirchner into a highly interesting circle of intellectuals, including Botho Graef, professor of archaeology and art history, and his friend Hugo Biallowons (ill. p. 92). Kirchner was attracted to these liberal and open-minded people, who might also prove helpful as patrons and perhaps even replace the artist friends he had lost.

The year 1914 marked the culmination of the so-called street scenes. Six years previously Kirchner had first struck the fundamental chord of the "symphony of the great city" in his renderings of passers-by and their confrontation with the viewer, and begun to view the cityscape as a psychological space (ill. p. 29). In 1913 he had returned to the theme with an unprecedented creative fervour. It was this dedication that made the series of street scenes, despite their limited number, one of the artist's most outstanding achievements.

Instead of being views of the city like *Red Elisabeth Embankment* or *Belle-Allianz-Platz* (ills. pp. 54 and 55), these were images of human beings in the city – that is, figurative paintings, a genre high on the list of the academic canon. Even Kirchner, that supposedly dyed-in-the-wool revolutionary and anti-bourgeois artist, wished to be measured by this yardstick, wanted to go down in art history not as a landscapist but a painter of figures. When after the First World War the Berlin Nationalgalerie selected three of his canvases for acquisition, all of them

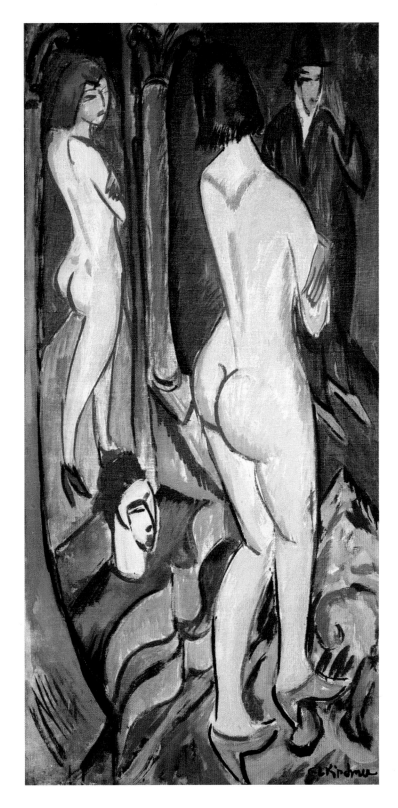

***Nude Viewed from the Back with Mirror
and Man,*** 1912
Oil on canvas, 160 x 80 cm
Berlin, Brücke-Museum

Kirchner's girlfriend Erna Schilling modelled
for the figure of the prostitute.

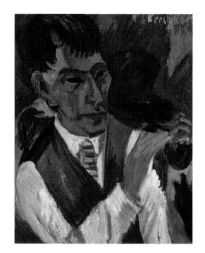

Otto Mueller with Pipe, 1913
Oil on canvas, 60 x 50,6 cm
Berlin, Brücke-Museum

Self-Portrait; Double Portrait, 1914/15
Oil on canvas, 60 x 49 cm
Berlin, Staatliche Museen zu Berlin –
Preussischer Kulturbesitz, Nationalgalerie

In view of the outbreak of war, Kirchner depic-
ted himself and his partner Erna as if in a com-
munity of fate.

PAGE 59:
*An Artists' Group: Otto Mueller, Kirchner,
Heckel, Schmidt-Rottluff,* 1926/27
Oil on canvas, 168 x 126 cm
Cologne, Museum Ludwig

Erich Heckel, the true initiator of Die Brücke,
stands in the middle, with Karl Schmidt-Rottluff
to the right and Kirchner on the left, pointing to
his chronicle of the group. Otto Mueller sits in
the foreground; Max Pechstein is missing.

views of Fehmarn and cityscapes (including *Staberhof Farmstead,* ill. p. 52), Kirch-
ner personally saw to it that Germany's most important museum of contempor-
ary art purchased one of his street scenes: *The Street,* 1913 (ill. p. 60).

The series began with a view of Cologne finished in 1913, *Five Women in the
Street* (ill. p. 61). It shows women walking down the sidewalk, picked out of the
nocturnal darkness by the light of streetlamps, on the right a suggestion of a dis-
play window, to the left the wheel of a car – all depicted in a fragmented perspec-
tive. This became the prototype for most of the following street scenes, an ap-
proach with which Kirchner lifted individual figures out of the anonymity of the
masses. The urbane if somewhat garishly made-up women strike attitudes, doing
their best to seem aloof and uninterested. They are cocottes like those who fre-
quented Friedrichstrasse (location of Café National, then the best-known prosti-
tutes' gathering place in town) and the vicinity of Potsdamer Platz. There, as Ste-
fan Zweig (1881–1942) wrote, the "pavements [were] so dotted with women for
sale that it was harder to avoid than to find them."

The next paintings, too, *Berlin Street Scene* and *Friedrichstrasse, Berlin* (ills.
pp. 62 and 63), depict prostitutes like slender, wary birds of prey, an impression
underscored by the aggressive zigzag hatching and the bizarre hats and feather

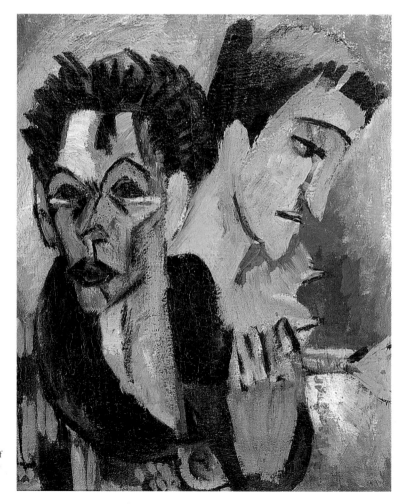

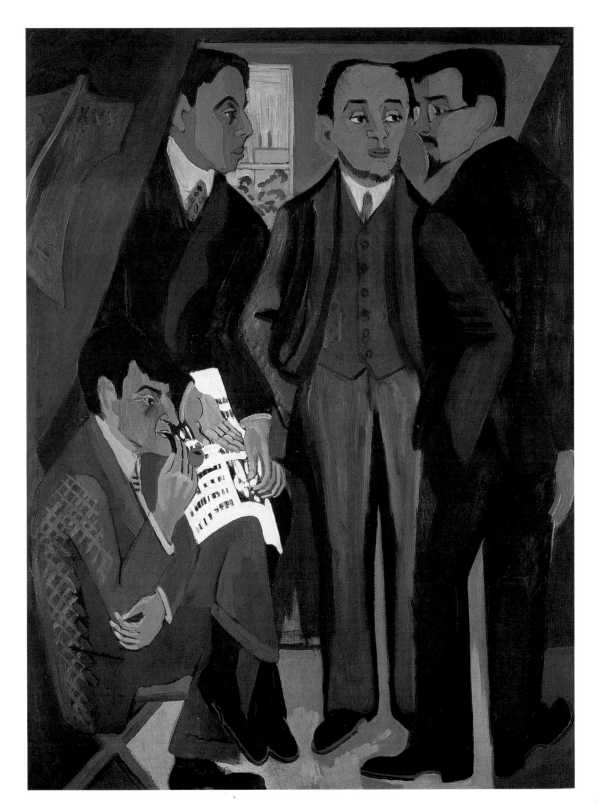

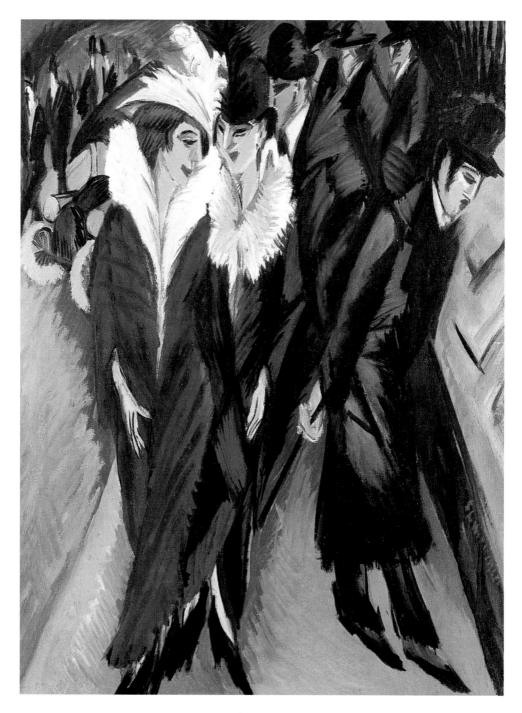

The Street, 1913
Oil on canvas, 120.6 x 91.1 cm
New York, The Museum of Modern Art, Purchase

This painting was confiscated as "degenerate" by Nazi officials
and acquired in 1939 by the most significant museum of modern
art in the world, The Museum of Modern Art, New York.

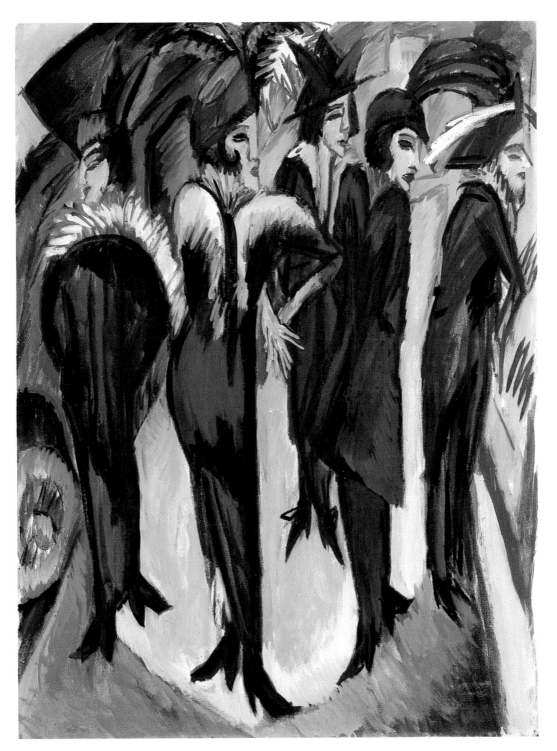

Five Women in the Street, 1913
Oil on canvas, 120 x 90 cm
Cologne, Museum Ludwig

Berlin Street Scene, 1913
Oil on canvas, 121 x 95 cm
Berlin, Brücke-Museum

Two Women in the Street, 1914
Oil on canvas, 120.5 x 91 cm
Düsseldorf, K20 Kunstsammlung Nordrhein-
Westfalen

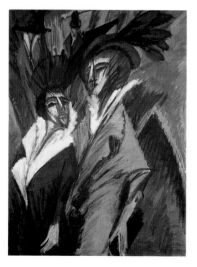

boas of these "birds of the night". Their breasts pressed up by tight corsets, they signal their readiness to potential customers, a phalanx marching by on stiffly angled legs. All of the figures seem irresistibly caught up in a cinematic rhythm of sexual attraction and repulsion; yet with their eyes narrowed to dangerous slits, they also suggest big cats prowling the urban jungle.

In *Friedrichstrasse* we see a glimpse of a speeding car and a whippet "with the innocence of Franz Marc's deer, scurrying gracefully and endangered into the dark of the night," as Roland März writes. The dynamic sequence of male figures definitely recalls the multiplication of form in *Plastic Overview of the Movements of a Woman*, by the Futurist Luigi Russolo (1885–1947). Kirchner's pastel drawing *Red Cocotte* (ill. p. 64), whose all-dominating red-clad streetwalker, "urban queen of eros for hire" (März), stalks her hunting ground followed by a wedge of faceless males rendered in an acute perspective. This image, like the oils *Two Women in the Street* and *Leipziger Strasse with Electric Trolley*, exemplify the "feathered" brushwork that Kirchner had developed in the course of the year out of the loose texture of the Fehmarn canvases. Unleashing what Eberhard Roters calls a "storm of strokes", he charged his imagery to the utmost with expressive energy. The same is true of the last of his street scenes, *Women in the Street*, 1915 (ill. p. 2).

Yet this work was preceded by a masterpiece, the monumental oil *Potsdamer Platz* (ill. p. 65), which has gone down in art history as an icon of German big-city Expressionism. From Kirchner's studio it was a fifteen-minute ride on the Wannsee suburban line to Potsdam Station, his point of departure for ramblings through the heart of the city: Potsdamer and Leipziger Platz, Friedrichstrasse, Unter den Linden, Pariser Platz with Brandenburg Gate. The red brick of the station gleams in the background. In the foreground stand two streetwalkers of different ages, both "ladylike", as police regulations demanded. Behind them hover black-suited men, anonymous, faceless. The triangle of pavement, its shape echoed by the striding legs of the male figures, is thrust like a lance between the converging streets toward the round traffic island, where the female figures stand as if on a revolving stage. Both forms possess clear sexual connotations. The street is suffused by a noxious green, which, to again cite Roland März, "fans out in a cold light on wet asphalt, overflowing the banks between pavement and traffic island, inundating it."

Today considered an archetypal modern analysis of big-city life, the picture was heaped with derision when it was first shown. To quote the review by Franz Servaes, in the *Vossische Zeitung* for February 16, 1916: Kirchner "presents true monstrosities of human figures with distorted limbs, doing ridiculous hopping movements in a surrounding space that totters as if drunk." The artist himself, having lived his love-hate of Berlin to the hilt, summed up his achievement quite differently: "Kirchner has developed and deepened both the What and the How of his painting in every way in Berlin."

The fact that one of the women in *Potsdamer Platz* wears a black widow's veil indicates that the picture was not finished until after August 1, 1914. That day marked the outbreak of World War I, and from then on, prostitutes were required to dress as soldiers' widows on Berlin's streets – strangely patriotic whores! When war broke out, Kirchner and Erna rushed back to the city from Fehmarn island, which had been declared a restricted military zone. In their train compartment they were temporarily arrested as spies. Back home, the artist fretfully awaited being inducted and sent to the front (ill. p. 58). He drowned his worries in absinthe – according to Erna, about a litre a day.

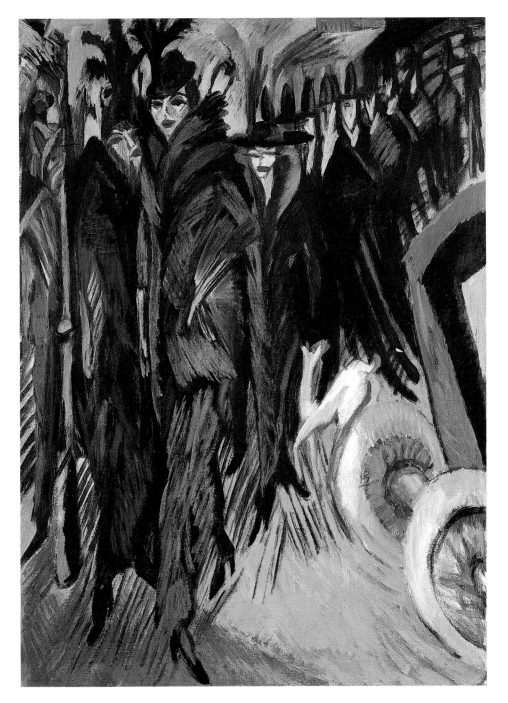

Friedrichstrasse, Berlin, 1914
Oil on canvas, 125 x 91 cm
Stuttgart, Staatsgalerie Stuttgart

The big-city scene is transformed into a maelstrom
of conflicting and threatening forces, evoked in a
style that owes much to Italian Futurism.

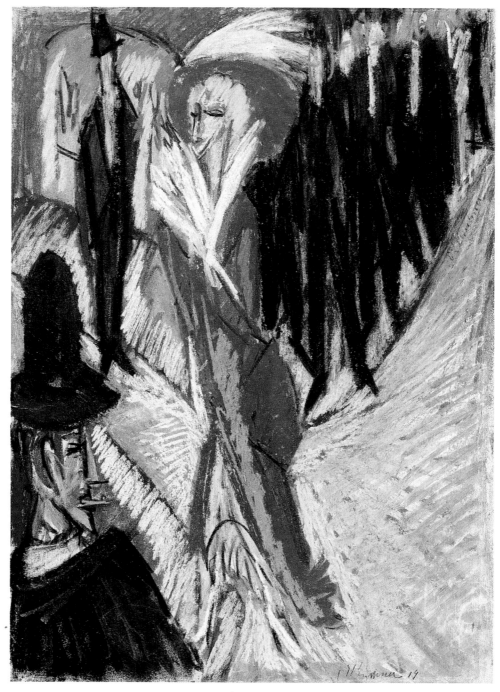

Red Cocotte, 1914
Coloured pastels on paper, 41 x 30 cm
Stuttgart, Staatsgalerie Stuttgart

In the 1920s Kirchner reworked the related oil painting
(Madrid, Museo Thyssen-Bornemisza) so extensively that
nothing of the composition's original eruptive character remained.

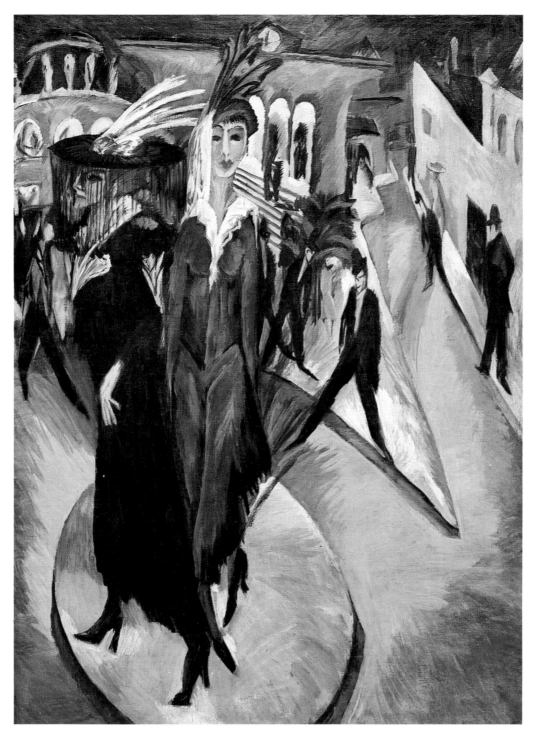

Potsdamer Platz, Berlin, 1914
Oil on canvas, 200 x 150 cm
Berlin, Staatliche Museen zu Berlin –
Preussischer Kulturbesitz, Nationalgalerie

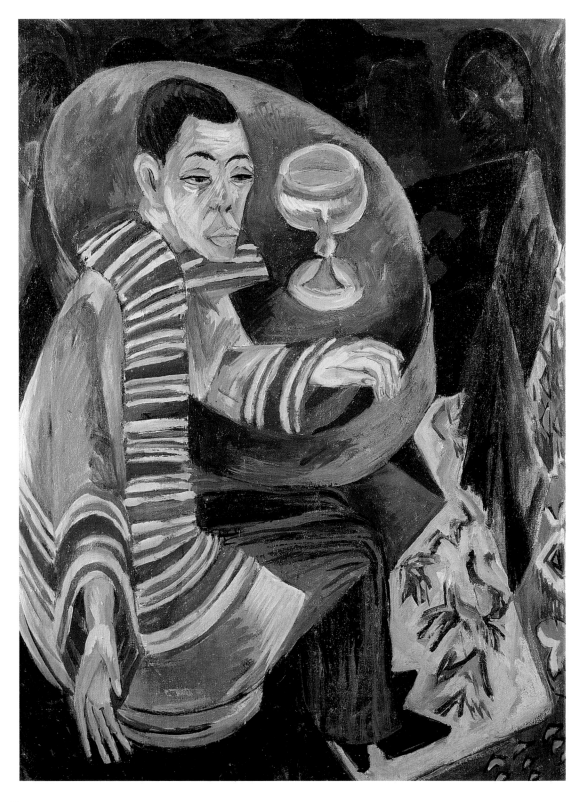

"Berlin, you dance with Death"

Death danced in and with the sabre-rattling city, wrote Walter Mehring (1896–1981), author and acerbic Dada poet, after the end of the War. In the summer of 1914, a dance of death was still far from people's minds. On the contrary, as Ernst Jünger (1895–1998) recalled in retrospect: "War simply had to bring us grandeur, strength, dignity. To us it seemed a masculine act, a merry shootout on blossoming, blood-bedewed meadows. No finer death was there in the world…"

Day and night, troop trains rattled by under Kirchner's window on Körnerstrasse, off to fight for the "beloved Fatherland". Academics, intellectuals, students and the prosperous, bored middle classes proved especially prone to chauvinistic hysteria, whereas ordinary people tended to be less susceptible. Their doubts were shared by only a small number of artists, including George Grosz (1893–1959). In contrast, Ernst Barlach (1870–1938), Lovis Corinth (1858–1925) and Max Liebermann enthusiastically chimed in with the Kaiser's choir. War euphoria swept through Europe from end to end. The Futurists had long since declared war to be "the only hygiene for the world". Franz Marc (1880–1916) expected war to bring a worldwide catharsis and the triumph of Expressionism. Max Beckmann and Otto Dix (1891–1969) volunteered for service; Schmidt-Rottluff looked forward to the chance to create something "as powerful as could be". These visions soon turned into bloody nightmares in the trenches, shell-holed fields, and overflowing field hospitals of France and Flanders.

Kirchner's reactions to events were highly ambivalent. He spoke about the army's "exalted mission in the field" and in 1915, aged thirty-five, signed up for military service, "an involuntarily volunteer", as he put it, hoping to be able to choose his own detail. In July he began basic training with the 75th Field Artillery Regiment in Halle. At this point Kirchner completed a self-portrait he had begun before his induction, an image in which existential anxiety is heightened into a symbol: *The Drinker; Self-Portrait* (ill. p. 66). With emaciated, stark, masklike negroid features, the artist sits in front of a glass of something noxious green. This is absinthe, that vermouth brandy that in late-nineteenth-century France had come to represent the quintessence of artists' self-destructive tendencies and a key theme in painting, from Toulouse-Lautrec (1864–1901) to Picasso (1881–1973).

An extremely high vantage point gives the table in the painting the appearance of a halo around the drink. The perspective tips the interior upwards and out into the picture plane, seemingly robbing the man on the sofa of support.

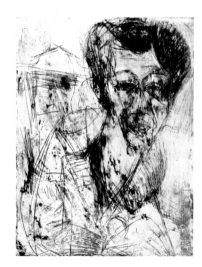

Self-Portait, Drawing, 1916
Drypoint and corrosion, 40.4 x 30.8 cm
Berlin, Brücke-Museum

The Drinker; Self-Portrait, 1914/15
Oil on canvas, 118,5 x 88,5 cm
Nuremberg, Germanisches Nationalmuseum

This painting was exhibited in 1917 under the title *The Absinthe Drinker* at Jenaer Kunstverein, where it was acquired by Kirchner's friend, the poet Karl Theodor Bluth. When Bluth decided to make it available on loan to the Munich Staatsgalerie, the artist hastened to buy it back in 1921, explaining that it was "not a picture that is understandable or beneficial for the general public."

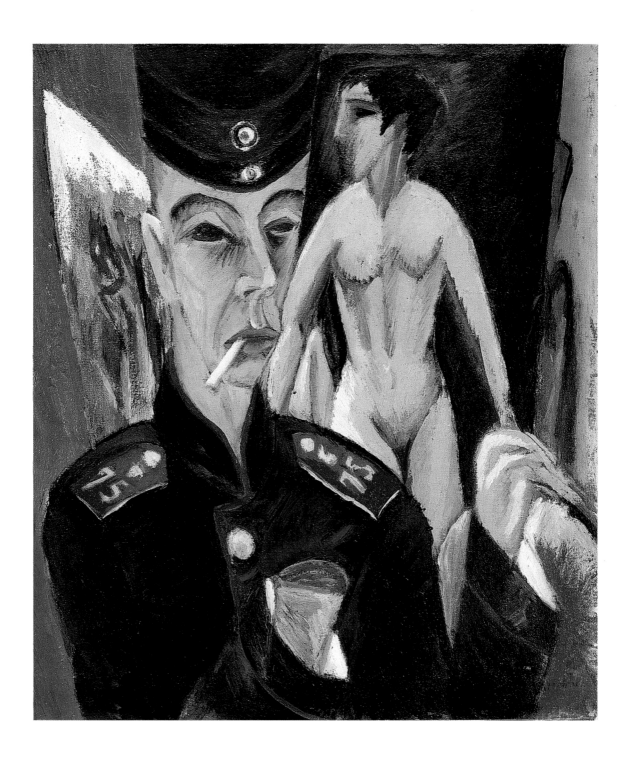

Self-Portrait as a Soldier, 1915
Oil on canvas, 69,2 x 61 cm
Oberlin, Ohio, Allen Memorial Art Museum,
Oberlin College, Charles F. Olney Fund, 50.29

Visible on Kirchner's cap are the two cockades
of Prussia and Imperial Germany, and on the
epaulettes, the number of his artillery regiment,
the 75th.

PAGE 69:
The Red Tower in Halle, 1915
Oil on canvas, 120 x 91 cm
Essen, Museum Folkwang

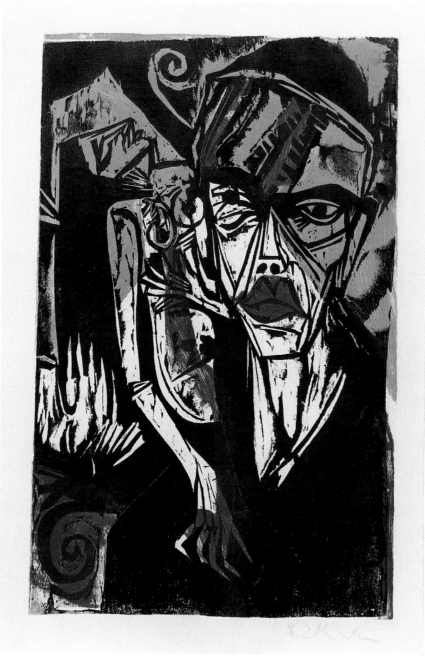

Struggles (The Torments of Love), 1915
Colour woodcut in black, red and blue, 33.6 x 21.4 cm
Berlin, Brücke-Muserum

Schlehmil in the Loneliness of his Room, 1915
Colour woodcut in black, brown, blue, red and yellow,
33 x 23.8 cm. Berlin, Brücke-Museum

Kirchner himself described his depiction of the hero of the story as follows: "Over his shoulder, with garish yellow intensity, the shrill mocking laughter of the pursuing mob follows him into his dark chamber … With a hardly surpassible eruptive shaping impulse that violently attacks his personal appearance and raises it to grotesqueness, Kirchner mercilessly visualizes his view of Schlehmil as 'paranoid'."

Königstein Railway Station , 1917
Oil on canvas, 94 x 94 cm
Frankfurt am Main, Deutsche Bank AG

The present oil must have been one of the first Kirchner executed in Davos, or in memory of his first stay there. In an article for a Swiss newspaper, the artist stated, "I was born near a railway station. The first things I saw in my life were the moving locomotives and trains; I drew them when I was three years old. Maybe that is why the observation of motion especially stimulates me to create."

The colourful shawl collar and cuffs of the dressing-gown frame his face and lift it out of reality, as if it were some emaciated, exotic idol. Kirchner imitates the pathos gesture of Christ as the Man of Sorrows, yet at the same time decks himself out in high-heeled shoes like some marionette. The empty gaze of a drug abuser seems directed nowhere except into hopelessness.

Military drill once again plunged Kirchner into mental distress, which he once again tried to take lightly, as in a greeting card sent to Heckel in 1911: "I'm suffering from serious depression again / The hell with it / Best wishes, Ernst." Yet distress soon gave way to panic. As as result, the city he was garrisoned in metamorphosed into an apocalyptic scene (ill. p. 69). The broad, deserted marketplace of Halle appears in distorted perspective, suffused with an icy blue. Two streets flow into the square like streams of blood, wedging in the city's freestanding, near-black belltower on its red brick foundation, as a cloud front gathers on the horizon. In his famous *Self-Portrait as a Soldier* (ill. p. 68), the most poignant sign of his mental crisis, Kirchner depicted himself in his Berlin studio during a leave. The nude woman in the background embodies both his lover and his beloved art. The painter poses with all the attributes of his military role and – with a severed right hand. War, Kirchner feared to the bottom of his soul, would rob him of the artist's most important tool. His empty gaze is redolent with despair. His uniform is like a straitjacket.

That same year, Kirchner created a series of seven woodcut illustrations to Adelbert von Chamisso's (1781–1838) *The Strange Story of Peter Schlehmil* (1814), a fairy-tale novella in the Romantic spirit that tells of a man who sold his shadow and placed himself beyond the pale of human society as a result. These woodcuts, in which Kirchner projected his own tormenting doubts into the image of Schlehmil, are among the major printmaking achievements of the twentieth century. They evoke visions of borderline states, suggest that intoxication, hypochondria, illness and insane asylum are the only escapes from the realities of war.

Sheet III, *Struggles (The Torments of Love)* (ill. p. 70), shows a naked, tormented woman gripping her bleeding heart and reaching out with a blood-red, clawlike hand towards the artist's breast. Jagged, splintered shapes and sheaves of line cleave the plane like wounds, clash and burst asunder; a ray of light emerging from the right eye of the portrait symbolizes a visionary recognition of the situation. Yet perhaps the most powerful image in the series is the following one, Sheet IV, *Schlehmil in the Loneliness of his Room* (ill. p. 71): an emaciated nude figure cramped into a boxlike interior, a man reduced to a leathery physical shell who is unable to conceal his panic any longer.

In September 1915, after just two months in the artillery, Kirchner was temporarily discharged, on the condition that he undergo psychiatric treatment. In early November he was declared unfit for military service until his complete recovery. He owed this reprieve to one of his instructors, Hans Fehr, in civilian life a professor of law at Halle University and earlier a passive member of Die Brücke. In the latter half of December, Kirchner entered a sanatorium run by Dr Oscar Kohnstamm in Königstein, in the Taunus mountains. He would make three stays of several weeks each there until summer 1916. The expenses were largely paid by friends. Kirchner was diagnosed with a nervous breakdown induced by excessive consumption of nicotine, alcohol and Veronal, or barbitol, a sleeping prescription. The threat of having to return to the army tormented him. He wrote of a "bloody carnival", and added, "Now one is just like the cocottes I used to paint. Blurred, then gone the next moment…" Kohnstamm,

Head of Dr Grisebach, 1917
Woodcut, 34 x 28,5 cm
Essen, Museum Folkwang

probably for therapeutic reasons, suggested that Kirchner decorate a room in the sanatorium. His first fresco design for the dining hall was not well received by either doctors or patients. Finally, in summer 1916, murals depicting bathers were completed in the spa pump room. They were destroyed by order of a Nazi gauleiter in 1938.

In early December 1916, Kirchner voluntarily entered the Edel mental hospital in Berlin-Charlottenburg. Whether the reason, symptoms of paralysis, was again due to Veronal or to an earlier case of syphilis – the artist had had sexual relations with the infected Gerda Schilling in 1913 – could not be clearly determined. Despite the chance that his drug and alcohol addiction could be cured in Berlin, Kirchner's parents and brothers soon secured his release from the sanatorium, not wanting him kept in what they viewed as a "lunatic asylum".

At that period Kirchner's pencil and etching needle seemed to trace every tiniest ramification of his nervous system. In *Self-Portrait, Drawing* (ill. p. 67), a loss of self and a ghostly dissolution, articulated in a web of hypersensitive hatchings, suggestions and empty spaces, astonishingly gel into a composed and balanced visual pattern of great power, underscored by the graphic and material values.

Luckily Kirchner still had a few friends left. Eberhard Grisebach in Jena, and Grisebach's mother-in-law Helene Spengler, wife of the pulmonary specialist Dr Luzius Spengler, medical director of the Schatzalp Sanatorium, arranged for him to travel via Stuttgart to Davos in Switzerland, where Kirchner arrived on January 19, 1917. Able to stand the sanatorium for only two weeks, that "pitiable figure for whom one had to feel sorry," as Helene Spengler described him, returned to Berlin. Yet by that May, Kirchner was already back in the fashionable spa of Davos, this time to stay. Dr Spengler not only confirmed his Veronal habit but detected a morphine addiction Kirchner had developed during his various sanatorium sojurns. The artist moved for two months into the high mountains, which now increasingly began to cast their spell over him. He lived in a cabin, "Rüeschhütte", on the Stafelalp above Frauenkirch, a few kilometres south of Davos (ill. p. 79). Kirchner was bedridden, suffering from nervous paralysis in his hands and legs. During this period he was able to draw and make prints, but seldom to paint.

There now emerged the earliest drawings and woodcuts devoted to the new and overwhelming experience of the Alps, their landscapes and people, imagery done with the same hypernervous approach and feverish lineatures as that of the first war years. When the Belgian architect Henry van de Velde (1863–1957), who had close ties with Kirchner's friends in Jena, visited him in Davos, he noted: "… a true victim of war; a hellish delusion of being sent back into battle had confused him … In Davos I found an emaciated man with a penetrating, feverish gaze … He seemed dismayed to see me at his bedside; he pressed his arms convulsively to his chest. He kept his passport hidden under his shirt like a talisman, as if it and his residence permit for Switzerland could save him from the clutches of imaginary enemies who wanted to turn him over to the German authorities."

A close friendship developed between Kirchner and van de Velde's daughter, Nele, which would last until 1924. Van de Velde also arranged to have Kirchner enter psychiatric treatment with Dr Ludwig Biswanger, in Kreuzlingen on Lake Constance. He remained there until the summer of 1918, and made the acquaintance of the collector Georg Reinhart, of Winterthur. His health now began to improve markedly. Kirchner was able to resume painting in oils, producing can-

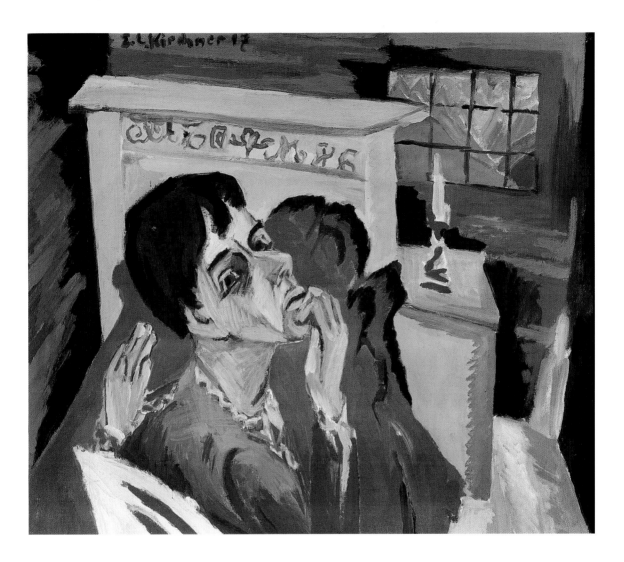

Self-Portrait as a Sick Man, 1918/1920
Oil on canvas, 57 x 66 cm
Munich, Pinakothek der Moderne

The picture, which focuses on Kirchner's lone-
liness on the Stafelalp during the summer of
1917, was painted in Kreuzlingen, where the
artist went to take a cure at the Bellevue sana-
torium from September 1917 to July 1918. He
painted over the oil in 1920.

vases such as *Self-Portrait as a Sick Man*. Here he depicts himself retrospectively
as a morphine addict, lying in bed in a blue Grisons peasant smock, gazing at the
mountains as if into some promised land. In the meantime Kirchner, initially
accompanied by a male nurse from Binschwanger Sanatorium, had moved into
a new farmhouse immediately below the Stafelalp called "In den Lärchen" (In the
Larches). His Berlin studio was taken care of by Erna Schilling.

When the war ended in November 1918, the artist's fear of being re-conscripted
passed. Things began to improve. Gustav Schiefler was preparing a catalogue of
Kirchner's prints, and Eberhard Grisebach was writing a book about him. Swit-
zerland had become a second home for Kirchner, who from this point on would
return to Berlin only infrequently and for brief periods.

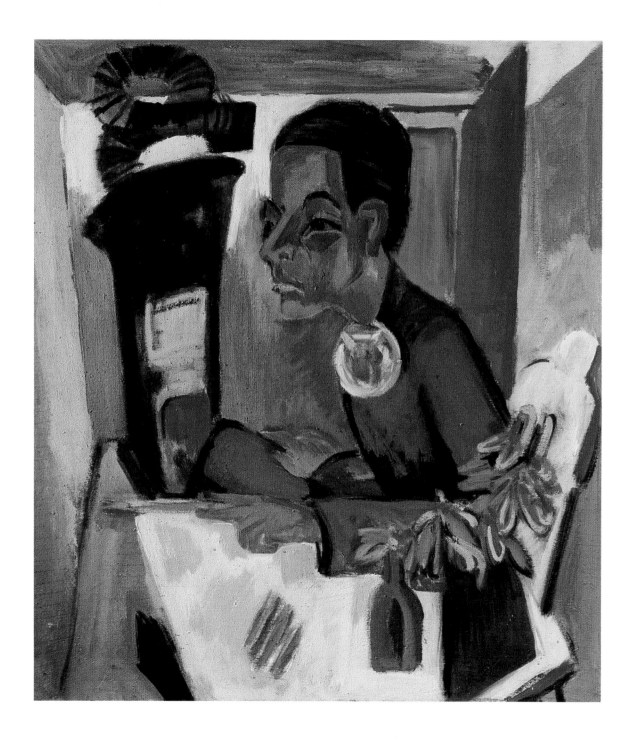

"Outsider here, outsider there"

Kirchner entered these words of complaint about his loneliness and isolation in his Davos journal on December 21, 1925. Yet he had always tried to turn such feelings to the advantage of his art: "My work emerges from the yearning of loneliness. I was always alone, the more I mingled with people, the more lonely I felt, shut out although no one shut me out. That brought deep sadness, and it yielded thanks to work…" This was written in 1919, when luck seemed to have returned to Kirchner in his cabin on Stafelalp (ill. p. 79). The "outsider" felt more and more at home in the little Swiss farmhouse, and began to discover the people around him. A portrait like *Old Farmer* shows the sympathy Kirchner now began to feel for the ordinary rural populace. *Alpine Cattle Drive* is one of several monumental depictions of farming life done in 1919 (ill. p. 80). It shows cattle being driven up to the high pastures in the early morning, a dignified, symbolic procession into the sublimity of the Alpine realm. A similar heightening of the effects of light to an almost sacred glory is seen in the extremely dynamic *Stafelalp in the Moonlight*, 1919 (ill. p. 81), a vision shot through with pathos.

A self-portrait done at this period, *The Painter; Self-Portrait* (ill. p. 76), conveys a mood of solemn peace of mind. Yet it is rendered in audacious, glowing colour combinations that seem to signal a newfound optimism. Profoundly concentrated on his task, Kirchner sits at his worktable in front of a canvas, next to him a vase of rhododendrons, behind him the cosy stove. Stylistically, the composition links up with *Self-Portrait with Cat* (ill. p. 6), although there the contemplative, introspective aspect of the face was more subtly evoked. Despite the fact that he was on the way to physical and mental recovery, Kirchner still had many bridges to cross. His craving for morphine had not been overcome, and would not be until 1921, and then only temporarily.

In 1918, in a woodcut series on the story of Absalom (ill. p. 82), Kirchner interpreted the Old Testament father-son conflict entirely in the light of his own biography and his difficulties with his parents. His estrangement, though he suffered from it, was basically unavoidable. When his father died of a heart attack on February 14, 1921, the erstwhile rebel found himself able to accept his emotions again: "I feel the loss greatly, despite the fact that we hardly knew each other." Kirchner even wore a black crepe mourning band on his coatsleeve, something he earlier would have rejected as "bourgeois". His reaction to the death of his mother in December 1928 was the same: "My mother died yesterday. It touched

Old Farmer, 1919/20
Oil on canvas, 90 x 75 cm
Bernried, Buchheim-Museum

The Painter; Self-Portrait, 1919/20
Oil on canvas, 90.8 x 80.5 cm
Karlsruhe, Staatliche Kunsthalle

me very deeply, despite the fact that I really had no intellectual contact with her … Now that she is gone, the door of my parents' home has closed forever. Even if it perhaps only existed in my imagination, because of course I was always the black sheep of the family, the play of dreamed-of possibilities has … truly come to an end." Kirchner was always willing to look deeply and mercilessly into his own complex inner life. When Helene Spengler asked him in 1919 about a potential marriage with Erna Schilling, he replied: "I have a feeling of endless gratitude for this woman, the duty to repay her to the utmost of my ability for everything she has selflessly and faithfully done for me, but love, that fully and completely unquestioning feeling two people have for one another – this I do not have … This feeling has gone into my activity."

The feeling Kirchner spoke about here, his deepest sensibilities, began increasingly to flow into pure landscape around 1919. The resulting oils and woodcuts are among his finest achievements, be it the many versions of the immensely expressive *Weatherbeaten Firs* (ill. p. 83) or the mystical *Tinzenhorn, Zügen Gorge near Monstein*. "I dream of a Tinzen picture at sunset, just the mountain, blue against blue, very simple," Kirchner noted in his diary, aptly characterizing this truly dreamlike merger of darkly glowing colour fields with comprehensive, reduced forms. The artist who had only recently captured the agitation of urban life on the eve of war now, in the face of the mountain realm, became an astonished depictor of a profoundly emotional experience of nature. The overwhelming force of this impression went far beyond that made on him by the Moritzburg Lakes and Fehmarn. It perhaps can be meaningfully described only by resort to a paradox – "Expressionist romanticism".

Tinzenhorn, Zügen Gorge near Monstein,
1919/20
Oil on canvas, 119 x 119 cm
Davos, Kirchner-Museum

The Tinzenhorn, a peak that dramatically closes off Davos Valley to the south, was the focus of many of Kirchner's landscapes at this period.

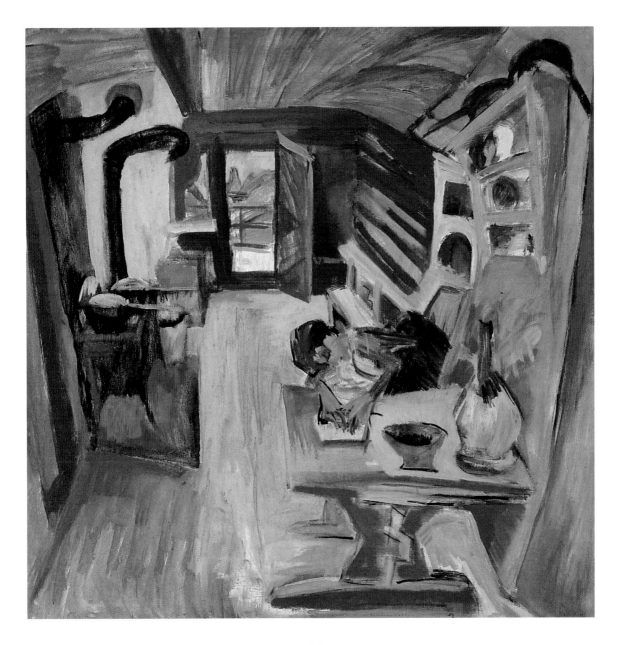

Alpine Kitchen, 1918
Oil on canvas, 120 x 120 cm
Madrid, Museo Thyssen-Bornemisza

While German art historians have tended to view this transformation as no more than marginal, a sign of a world-weary escape, the Swiss have rightly placed Kirchner in the great tradition of Alpine painting (ill. p. 81), alongside Giovanni Segantini (1858–1899) and Ferdinand Hodler (1853–1918). Indeed, a painting like *Winter Moonlight Landscape*, 1919 (Detroit, Art Institute), and even more the colour woodcut based on it, *Winter Moonlight Night* (ill. p. 83), count among Kirchner's most compelling achievements.

A year later Kirchner received an unexpected commission. The committee of the Davos-Frauenkirch mixed choir enquired whether he would like to design stage sets for a play, with edelweiss and Alpine roses against a background of snow-capped peaks, mountain cabins and Marterl shrines. Kirchner enthusiastically accepted the job, but largely ignored the choir's ideas. With sweeping brushstrokes he covered the carefully primed surface with expansive colour fields and agitated calligraphy (ill. pp. 84/85). This was his largest Alpine landscape ever, what Lothar-Günther Buchheim has called an "enormous depiction of mountain nature … a saga of trees and rocks, of the mighty primal nature of the high mountains. All of his pictorial experiences flowed into this composition…"

Now Kirchner's life began to grow more social. He went frequently to Davos, whose cafés he loved (ill. p. 86). On an excursion to Zurich in May 1921, he met Nina Hardt, a dancer. To Erna's chagrin, he invited Nina to Davos, where for invited guests she danced in the nude in a stage set designed by Kirchner at his home "In den Lärchen" (ill. p. 95). From his base in Switzerland, Kirchner kept

Alpine Cattle Drive, 1918/19
Oil on canvas, 139 x 199 cm
St. Gallen, Kunstmuseum

Kirchner's own dating of the picture to 1917 is certainly misleading.

Stafelalp in the Moonlight, 1919
Oil on canvas, 138 x 200 cm
Dortmund, Museum am Ostwall,
Gröppel collection

Kirchner described the conception of this painting in his Davos diary: "Wonderful moonlight. The three cottages on the mountain in the moonlight … very delicate, olive green, rose, blue and black, purplish-brown shadow tones and ochre."

up with the European art scene, returned to Germany a few times from the 1920s onwards, corresponded with friends, published, sent pictures to exhibitions. One of these, held in June 1923 at the Kunsthalle Basel, made such an impression on young Swiss painters that two years later they formed a group, "Rot-Blau" (Red-Blue), under Kirchner's aegis.

In 1921 Kirchner's style began to grow increasingly calm and considered. His expressiveness gave way to a more decorative balance, a very two-dimensional approach with more balanced proportions, a masterful tectonic monumentality, and a magnificent palette. "The changes in form and proportions," wrote the artist in 1922, in the exhibition catalogue of Galerie Ludwig Schames, Frankfurt am Main, "are not arbitrary, but serve to render the mental impression grand and

The Mountains, 1921
Oil on canvas, 124 x 168 cm
Frankfurt am Main, Deutsche Bank AG

Writing in retrospect about such pictures under the pseudonym Louis de Marsalle in 1927, Kirchner declared that he had been "the first artist since Hodler to paint the mountains in a new way."

compelling…" He described this process by the term "hieroglyph," implying a striking visual formula in which experienced and seen realities were translated into emotion-charged, compelling symbols. A good illustration of this is found in the woodcut *The Tree* (ill. p. 90). Kirchner now aimed at creating "out of pure imagination". Putting the ideals of Die Brücke behind him for good, he began to dream of a venerable, time-tested "high art," an art beholden to ideal compositional rules. This vision found further support when the artist met Lise Gujer in Davos in 1922, and she began to weave tapestries based on his designs.

Kirchner had always felt the need to transcend the limits of painting. In 1909 he had begun to carve figures in the round, reliefs and furniture; his numerous designs for book covers, bindings, endpapers and typography were highlights of modern book and catalogue design. And the collaboration with Lise Gujer just mentioned resulted in fascinating objects of textile art (ill. p. 90). If only for technical reasons, weaving required a reduction of form and an emphasis on two-dimensionality, and this in turn stimulated the change in Kirchner's style. The resulting regular, well-nigh simple compositional structure combined with brilliant colours is seen in the paintings *The Amselfluh* (ill. p. 91) and *Davos in the Snow* – the latter painted from the vantage point of Kirchner's

David Weeping for Absalom, 1918
Sheet VII of the woodcut sequence, 40 x 36.4 cm
Kassel, Staatliche Museen Kassel, Graphische
Sammlung

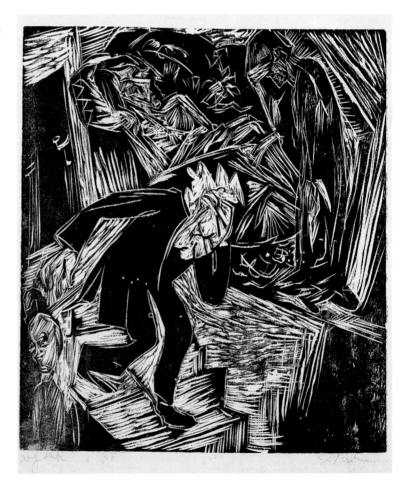

Weatherbeaten Firs, 1919
Colour woodcut from three blocks in black,
blue and green, 62 x 33,6 cm
Basel, Öffentliche Kunstsammlung,
Kupferstichkabinett

These firs stood on the path that led from Kirch-
ner's house, "In den Lärchen," up the Stafelalp.

new country house, "Auf dem Wildboden," where he moved in October 1923.
Kirchner's so-called "tapestry style" culminated in 1923–24, in the masterpiece
Alpine Sunday; Scene at the Well (ill. p. 88/89). As in a monumental frieze, the
procession of simplified rural figures gels into an epic "hieroglyph" for the
Alpine world.

Now, well into his forties and tending to a constructed abstraction as never
before, Kirchner began to compete with the greats of his generation – with Picasso,
Braque and Matisse, but also with Wassily Kandinsky (1866–1944), the leading
representative of the Blauer Reiter group of Munich Expressionists, as well
as with Paul Klee (1879–1940). His appreciation for the conceptual nature of
Bauhaus art increased – Fritz Winter (1905–1976), a Bauhaus student, visited
him in Switzerland in 1928, followed in 1933 by Oskar Schlemmer (1888–1943),
the brilliant choreographer of geometric yet still objective forms. The proximity
of Kirchner's cool, large-area compositions of the period to Neue Sachlichkeit,
or The New Objectivity, whose representatives he met at the "Internationale
Kunstausstellung Dresden" in 1926, is illustrated by canvases such as *Frankfurt
Cathedral* and *Street Scene by Night* (ill. p. 19). However, Kirchner's opinion of
such absolutely geometric abstractionists as Kasimir Malevich (1878–1935) and
Piet Mondrian (1872–1944) was less favourable, if not so cynical as his verdicts
on his former Brücke companions or other German artists like Max Beckmann
and Otto Dix.

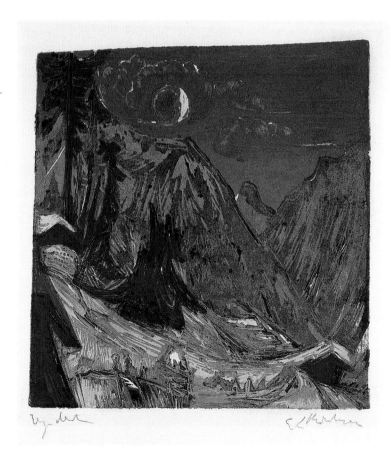

Winter Moonlight Night, 1919
Colour woodcut, 30 x 29,5 cm
Basel, Öffentliche Kunstsammlung,
Kupferstichkabinett

This woodcut was printed from nine separate
blocks. Ten versions with different colour
schemes and printing sequences have come
to light, each of them one of the most valued
collector's items in Kirchner's œuvre.

A Zurich exhibition brought Kirchner face to face with originals by Picasso in September 1925, and apparently encouraged a radical rethinking of his approach. This stylistic change came to a head thanks to weeks-long observation of the dance troupes of Mary Wigman and Gret Palucca in Dresden, in 1926. The broad, bandlike contour line again came to the fore, a line whose ornamental sinuosities reduced the areas it contained to the simplest possible terms. At the same time, Kirchner tried his hand at an adoption of Cubist devices, dividing motifs in accordance with the principle of multiple viewpoints and integrating several phases of movement simultaneously in the pictorial structure. Again, Picasso served as his Archimedean fulcrum in this regard.

An exhibition of the latter's work at the Zurich Kunsthaus in late 1932 confirmed Kirchner in his abandonment of his earlier emotional expressiveness. An elegant drawing executed in 1929, *Agitated Heads* (ill. p. 86), is exemplary of his Cubist-influenced brushwork, which, far from spontaneous, is used to create homogeneous planes, which are also seen in an oil finished three years later, *Horsewoman* (ill. p. 87). As a comparison with Cubist still-lifes indicates, in every case the contours are used to make every element and detail part of the two-dimensional plane and thus to negate the space that should actually lie between the forms and figures. In France, such rational constructions are aptly termed "architecture plâte et colorée" (flat, coloured architecture). As Kirchner

Landscape with Mountains and Forests, 1920
Oil on sacking, 220 x 600 cm
Bernried, Buchheim-Museum

himself stated, pictures of this type contained everything, "not just a part of art, as in so-called Impressionism, and no accidental perspective or random excerpts." Yet Kirchner's *Horsewoman* does not entirely do justice to this claim to absoluteness. As Lucius Grisebach rightly points out, "What Kirchner wished to have understood as form of a higher order, as abstract form, remained a stylization and monumentalization of the individual and random. The supraindividual claim to perpetual validity … is again and again impeded by entirely non-abstract details. While … the body of the horse … is intelligently divided into several mutually overlapping planes and at the same time condensed into a large, flat form, the figure of the horsewoman and the head of the horse lose themselves in a variety of motif details … which are in fact not abstract and therefore have the effect of caricatures."

These works indeed lacked something of the concision that had characterized Kirchner's earlier art. And they certainly did not look like that "Germanic art" whose leading protagonist Kirchner had claimed himself to be in his diary in 1923. By the mid 1930s he put an end to this relatively unproductive phase, in which theoretical reflexion had supplanted spontaneity. In 1934 Kirchner again began to devote himself to large-format works in which the paint was applied opaquely, even used to model forms in the round, and again yielded to the overwhelming impression of great expanses of landscape topography.

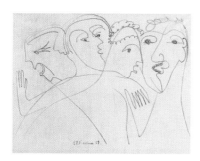

Agitated Heads, 1929
Pencil on paper, 33.8 x 46 cm
Düsseldorf, museum kunst palast

Let us look one last time into Kirchner's chequered biography. In 1927 he received a prestigious commission from Ernst Gosebruch, director of the Folkwang Museum in Essen, to decorate its festival hall with wall-filling frescoes. The project occupied him until 1934, when Nazi art authorities prevented its further execution. Kirchner had been accepted into the Prussian Academy of Arts in Berlin in 1931. Yet he was soon forced to realize how much the situation in Germany had worsened since Hitler's accession to power. Illnesses again began to take over Kirchner's body and mind. To alleviate the torment of what may have been cancer of the stomach or intestines, he began taking morphine-based pain killers in great amounts. More and more alarming news from Germany reached him in Switzerland.

In summer 1937, six hundred and thirty-nine Kirchner works in German museums were confiscated as being "decadent". Thirty-two of them, including *Nude Combing her Hair* (1913; ill. p. 49), were included in the travelling Nazi exhibition of supposedly degenerate art, "Entartete Kunst", where the crowds jeered and a few sympathizers kept their silence. Kirchner's reaction revealed a certain political naivety: "I had always hoped that Hitler was for all Germans, and now he has defamed so many and really serious, good artists of German blood. This is very sad for those affected, because they – the serious ones among them – all wished to, and did, work for Germany's fame and honour."

In July 1937 the Prussian Academy of Arts demanded that Kirchner relinquish his membership. On his fifty-eighth birthday, May 6, 1938, not a single congratulation came. That March the Wehrmacht had swept into Austria; German troops now stood less than twenty-five kilometres as the crow flies from Davos. Illness, despair over the political situation, and the knowledge of having been barbarically expelled from the pantheon of German art, increased Kirchner's depression and sense of isolation. One of his final paintings, *Flock of Sheep* (ill. p. 91), is a strangely calm and tranquil composition considering the emotional agitation in which the artist spent the last weeks of his life. He had reached the

Café in Davos, 1928
Oil on canvas, 72 x 92 cm
Kassel, Staatliche Museen Kassel, Neue Galerie

PAGE 87:
Horsewoman, 1931/32
Oil on canvas, 200 x 150 cm
Davos, Kirchner-Museum

Kirchner himself provided a description of this painting that sheds light on its implicitly Cubist approach: "In bright sunlight, distant shadows emerge as independent forms from solid bodies and combine with simplified outlines to create a new form. The various views obtained by walking around [objects] are here combined into a single, unified form."

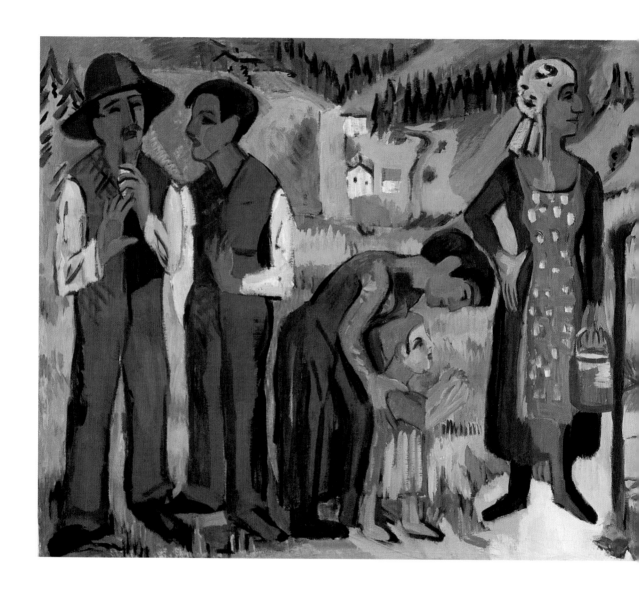

Sunday in the Alps; Scene at the Well, 1923/24
Oil on canvas, 168 x 400 cm
Bern, Kunstmuseum Bern

This picture was finished in a workroom speci-
ally rented for the purpose, since the rooms
in Kirchner's old farmhouse, "Auf dem Wild-
boden", were too small for the huge format.

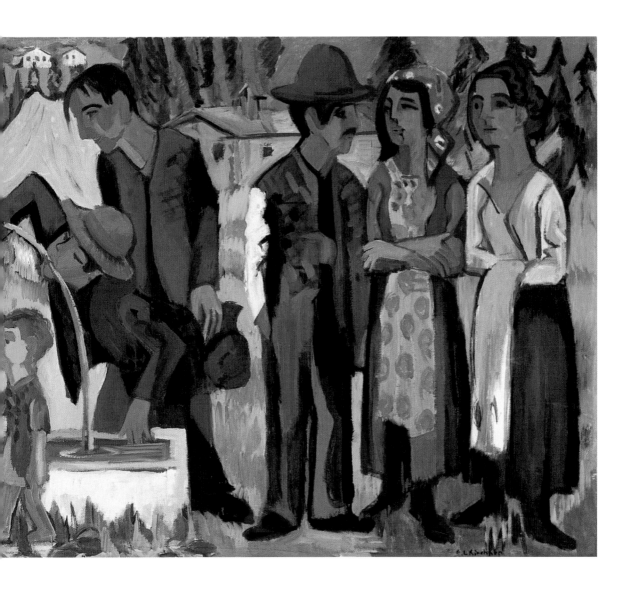

end of his tether. On Wednesday, June 15, 1938, he destroyed drawings, burned printing blocks and a number of wood sculptures. At about ten in the morning, outside his house "Auf dem Wildboden", Kirchner put a pistol to his heart and pulled the trigger. Three days later he was laid to rest at Waldfriedhof cemetery in Davos.

Kirchner left behind over one thousand oil paintings, several thousand pastels, drawings and prints, and dozens of wood carvings and textile designs. During the Weimar Republic he had been a major name in German art. Many important museums acquired his paintings at high prices. An early international breakthrough even seemed in the making: after participating in the Cologne "Sonderbund" Exhibition in 1912, he was one of the few German artists to receive an invitation to the renowned "Armory Show" in New York the following year. Yet neither this honour nor the several exhibitions of his work held in the U.S. from 1931 onwards were able to change the basically superficial evaluation of his œuvre abroad.

Paradoxically, the situation was complicated by the 1937 "Entartete Kunst" exhibition itself, which was used internationally to politically exploit Kirchner's and other Expressionist art as illustrating the stupidity of the Nazi bigwigs and

The Amselfluh, 1923
Oil on canvas, 120 x 170,5 cm
Basel, Öffentliche Kunstsammlung Basel

Kirchner himself variously dated the picture
to 1922 or 1923. The Amselfluh is a precipice
above Stafelalp, along whose base runs a popular
hiking path from Davos to Arosa.

their mudslinging in the name of racial purity. The works were welcomed and appreciated as means of propaganda. As far as their aesthetic value was concerned, art historians perpetuated the cliché that Expressionism stood completely in the shadow of the French avant-garde. It was not until 1968, with the publication of Donald E. Gordon's book on Kirchner, that this view underwent a radical change. Today experts and audiences agree that it would be difficult to overestimate the importance of Kirchner's fundamental, passionate and experimental role in twentieth-century art.

Flock of Sheep, 1938
Oil on canvas, 101 x 120 cm
Berlin, Brücke-Museum

It was long believed that this canvas was left
unfinished on the easel on the day Kirchner
took his life. Although this assumption has
proved untenable, we do know that it was
one of his last paintings.

Ernst Ludwig Kirchner 1880–1938
Chronology

1880 May 6: Ernst Ludwig Kirchner is born in Aschaffenburg, Lower Franconia. He is the eldest son of Ernst Kirchner (1847–1921), a successful engineer and chemist, and Maria Elise Malwina Bertha Franke (1851–1928). Both his father and mother came of business families in Brandenburg.

1882–1898 1882: birth of Ernst Ludwig's brother Walter (d. 1954). Four years later the family moves to Frank-furt am Main. 1887–1889: the Kirchners reside in Perlen, near Lucerne, Switzerland, where the artist's father serves as deputy director of the local paper factory. Ernst Ludwig enters school. 1888: birth of his youngest brother, Ulrich (d. 1950).

1890: the family moves to Chemnitz, where Ernst Kirchner becomes professor of paper research at the Trades Academy. Ernst Ludwig attends secondary school; a photograph of his first self-portrait in oil survives from this period.

1895: his father visits his boyhood friend, the aviation pioneer Otto Lilienthal, in Berlin. Ernst Ludwig, who accompanies him, dreams of becoming an aviator.

1901–1904 Spring 1901: on leaving school, Ernst Ludwig enrols at his father's behest in the architecture department of Saxon technical college in Dresden. During his first semester he meets Fritz Bleyl, a fellow freshman from Zwickau.

Winter semester 1903–04: attends Munich Technical College, taking courses primarily at an experimental studio for applied and fine art headed by Wilhelm von Debschitz and Hermann Obrist. He spends much time in museums and exhibitions, where

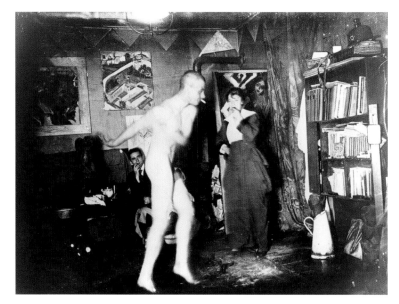

Werner Gothein, Hugo Biallowons and Erna Schilling in the Studio, 45 Körnerstrasse, Berlin-Steglitz, 1915
Photograph by Ernst Ludwig Kirchner

Kirchner transformed his studios into works of art in their own right. They were also scenes of a liberated sexuality, as shown here by Biallowons dancing in the nude. Kirchner deeply mourned the loss of his friend Biallowons, who was killed in action on the Western Front outside Verdun on July 9, 1916.

he discovers French Post-Impressionist works. On a trip to Nuremberg he is intrigued by the Dürer printing plates on view in the Germanisches Nationalmuseum. 1904: after resuming his studies in Dresden, Kirchner meets Erich Heckel.

1905 Becomes acquainted with Karl Schmidt-Rottluff. June 7: Schmidt-Rottluff, Bleyl, Heckel and Kirchner form Die Brücke in Dresden. Kirchner completes his architecture studies and is awarded his engineering diploma; yet he has long since decided on a career in art.

1906–07 Kirchner takes over Heckel's studio at 60 Berliner Strasse. Publication of the first annual Brücke portfolio. The group's first exhibition is held at the K.M. Seifert lamp factory, Dresden-Löbtau. Kirchner meets Doris Grosse, who subsequently becomes his mistress and, for a few years, his favourite model.
September 1–21, 1907: a large Brücke show, curated by Emil Richter, is held in Dresden.

1908 Kirchner sees works by Vincent van Gogh and the Fauves at exhibitions. Summer: first trip to the island of Fehmarn in the Baltic, accompanied by his model Emmy Frisch – who would later become Schmidt-Rottluff's wife – and her brother Hans. Begins work on *Street*, the first major painting in the street-scene series.

1909–10 Visits Pechstein in Berlin on two occasions. In January he has the opportunity to acquaint himself with the art of Matisse at a show at Galerie Paul Cassirer, and in November, at the same gallery, he sees paintings by Cézanne. Kirchner executes his first sculptures in wood.

Ernst Ludwig Kirchner in Chemnitz with the works he had done in Munich, 1904

Summer 1909: with Heckel, Pechstein and Doris (Dodo) Grosse, vacations at the Moritzburg Lakes for the first time. Begins a series of important paintings devoted to nudes in an outdoor setting. Kirchner also depicts models in the studio, a theme that culminates in *Artiste* and *Standing Nude with Hat*, both 1910. These, like views of the city of Dresden done in parallel, reflect the great level of skill Kirchner has by now achieved.

1911 July: after a large Brücke exhibition at Jena Art Association, Kirchner and Otto Mueller travel to Bohemia. October: moves to Berlin, establishing his first studio at 14 Durlacher Strasse, in the district of Wilmersdorf. Jointly with Pechstein, founds a school of modern art, MUIM ("Moderner Unterricht in Malerei"), which proves only short-lived.

1912 Kirchner meets his future companion, Erna Schilling, and her sister Gerda, as well as the writer Alfred Döblin. February: Die Brücke participates in the second exhibition of the Blauer Reiter group, at Galerie Hans Goltz, Munich. A further large show

in Hamburg follows. The Brücke artists are invited to the International Sonderbund exhibition in Cologne; Kirchner and Heckel are entrusted with decorating the building's chapel. Kirchner executes *Striding into the Sea*, a major work in the emerging series of nude figures in a landscape. The last six months of the year find Kirchner beginning a series of Berlin views.

1913 Kirchner writes a chronicle of Die Brücke, which meets with such resistance on the part of his confreres that it leads to the dissolution of the group. Kirchner has a first solo-exhibition. October: moves into a new studio in Berlin-Friedenau, at 45 Körnerstrasse.

1914 February: an important solo exhibition of Kirchner's work is held at Jena Art Association. He makes several friends on this occasion, including Eberhard Grisebach, a philosopher, and Botho Graef, professor of archaeology and art history. May: Kirchner participates in the Werkbund Exhibition in Cologne. Summer: travels to Fehmarn for one last time. Early

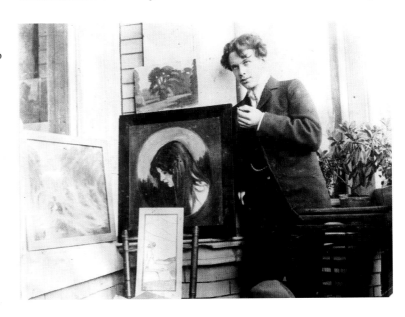

August 1914: on the outbreak of war, Kirchner volunteers for military service, opting to become a driver in an artillery regiment. With the painting *Potsdamer Platz*, his series of street scenes reaches its climax.

1915–1917 Spring 1915: Kirchner is called up as a recruit to a field artillery regiment stationed in Halle an der Saale. Due to "lung affliction and weakness" he is soon given leave of absence until October 29, then, in November, is discharged from active service pending his complete recovery. The depth of his anguish at that time is recorded in *Self-Portrait as a Soldier*. To summer 1916: Kirchner spends three periods at a sanatorium run by Dr Kohnstamm in Königstein, Taunus.
December 1916: he is admitted into another sanatorium, this time in the Charlottenburg district of Berlin. January 19 – February 5, 1917: on invitation of Grisebach's mother-in-law, Helene Spengler, wife of the pulmonary specialist Dr Luzius Spengler, Kirchner stays in Davos, Switzerland. May 8: he settles for good in the Davos region, where he receives a visit from the architect Henry van de Velde. September 15, 1917: On van de Velde's advice, Kirchner enters a sanatorium for nervous disorders run by Dr Ludwig Binswanger, in Kreuzlingen on Lake Constance, from which he will be released on July 9, 1918. He begins his major series of depictions of the Alpine region and its inhabitants.

1918–1922 October 1918: Kirchner moves into a farm cottage, "In den Lärchen", on Längmatte in Frauenkirch. Over the following years, increasing numbers of shows of his paintings and prints will be held in

Germany, most outstandingly, in February 1921, an exhibition of fifty works at Kronprinzenpalais in Berlin. That same year, in Zurich, Kirchner meets the dancer Nina Hardt. 1922: he befriends the tapestry weaver Lise Gujer, marking the start of a close collaboration.

1923 A large exhibition of Kirchner's work at Kunsthalle Basel triggers the founding of a Swiss artists' group, "Rot-Blau" (Red-Blue), whose members include Hermann Scherer (1893–1927), Albert Müller (1897–1926), and Paul Camenisch (1893–1970). At the end of the year, Kirchner settles in a roomier farmhouse, "Auf dem Wildboden", near Frauenkirch.
February 12: death of Dr Luzius Spengler, leading to the termination of Kirchner's so helpful relationship with Helene Spengler.

1926 Kirchner returns to Germany for the first time.

1927 Early summer: he receives a commission from Ernst Gosebruch to execute murals in the great hall of the new Museum Folkwang, Essen. Countless preparatory studies and sketches are made, but the project finally founders on the art policies introduced by the Nazis after 1933.

1928 A tax return submitted in Switzerland reveals Kirchner's difficult financial circumstances. It declares cash assets of 12,500 francs, furniture valued at 2,000 francs, and an income of 4,000 francs. Kirchner notes in his diary that he cannot afford a studio: "Of course I can manage without a studio, but it would be nice. Only I cannot make any concessions in order to achieve a higher income…"

1928–1933 1928: Kirchner participates in the Venice Biennale. 1931: represented in shows in New York and Brussels. 1933: works by Kirchner exhibited at Kunsthalle Bern.

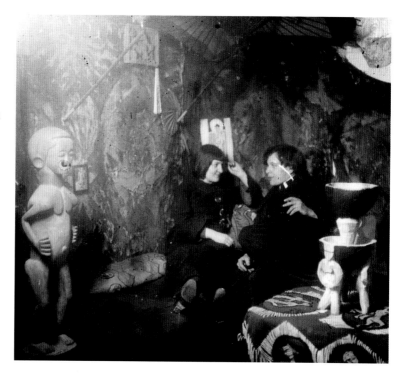

Erna Kirchner (Schilling) and Ernst Ludwig Kirchner in the Berlin-Wilmersdorf Studio, 14 Durlacher Strasse, c. 1912/14

1937 Kirchner has a significant solo exhibition at the Detroit Art Institute. In Germany, 639 of his works are confiscated from various museums by the authorities; thirty-two are included in the Munich exhibition "Entartete Kunst" (Degenerate Art). Kirchner is expelled from the Prussian Academy of Arts, of which he has been a member since 1931.

1938 May 10: Kirchner applies at Davos town hall for a proclamation of intended marriage with his long-time companion, Erna, presumably to ensure her legal claim to his estate – yet on June 12, he revokes the application.
June 15: weakened by persistent illness and drug addiction and overcome by despair, the artist commits suicide. Erna Schilling is granted the right to use the name "Kirchner", and continues to live in the Wildboden house until her death on October 2, 1945.

The dancer Nina Hardt standing in Kirchner's house "In den Lärchen," Frauenkirch near Davos, 1921
Photograph by Ernst Ludwig Kirchner

Photo Credits

The publishers wish to thank the museums, private collections, archives and photographers who granted permission to reproduce works and gave support in the making of the book, particularly Dr Wolfgang and Mrs Ingeborg Henze of Wichtrach near Berne. In addition to the collections and museums named in the picture captions, we wish to credit the following:

AKG, Berlin: 15, 20, 22, 31, 36 bottom, 56 bottom, 57, 59, 62 bottom, 65, 70, 71, 80; © Bildarchiv Preußischer Kulturbesitz, Berlin, photograph Jörg P. Anders: 55, 56 top, 58 bottom, photograph Klaus Göken: 24; Brücke-Museum, Berlin, photograph Roman März: 7, 13, 38 top; Kunst-museum Bern, photograph Peter Lauri: 46, 88/89; Fotoarchiv Bolliger/Ketterer, Wichtrach/Berne: 92–95; Courtesy of The Busch-Reisinger Museum/Harvard University Art Museums, Cambridge: 6, 43; Museum am Ostwall, Dortmund, photograph Jürgen Spiler: 81 top; © Max K. Pechstein, Hamburg, photograph Bernd Kirtz BFF, Duisburg: 35 bottom; K20 Kunstsammlung Nordrhein-Westfalen, Düsseldorf, photograph © Walter Klein: 42; © Museum Folkwang, Essen: 1, 74; © Scala Archives, Florence: 29, 49 top; Städelsches Kunstinstitut, Frankfurt/M., photograph Ursula Edelmann: 26; Hessisches Landesmuseum, Darmstadt, photograph Wolfgang Fuhrmannek: 45; © Pfalzgalerie Kaiserslautern: 27; © Staatliche Museen Kassel, photograph Ute Brunzel: 9; 21, 82, 86 bottom; © Rheinisches Bildarchiv, Köln: 12; Saarland Museum, Saarbrücken, photograph accent studios – Carsten Clüsserath: 32/33; © Staatsgalerie Stuttgart: 63, 64, 90 right; Artothek, Weilheim: 16, 44, 49 bottom, 50/51, 52, 60, 62 top, 69; Joachim Blauel – Artothek, Weilheim: 11, 14, 23, 35 top, 37, 40/41, 54, 61, 75–77, 78 right, 81 bottom, 84/85, 91 bottom; Blauel/Gnamm – Artothek, Weilheim: 38 bottom, 47; Ursula Edelmann – Artothek, Weilheim: 39; Hans Hinz – Artothek, Weilheim: 78 left, 91 top; Peter Willi – Artothek, Weilheim: 17; © MUMOK, Museum Moderner Kunst Stiftung Ludwig Wien: 25; Von der Heydt-Museum, Wuppertal, photograph © Medienzentrum Wuppertal: 2